Passionate Be

Passionate Being

Language, Singularity and
Perseverance

Yve Lomax

I.B. TAURIS
LONDON · NEW YORK

Published in 2010 by I.B.Tauris & Co Ltd
6 Salem Road, London W2 4BU
175 Fifth Avenue, New York NY 10010
www.ibtauris.com

Distributed in the United States and Canada Exclusively by Palgrave Macmillan
175 Fifth Avenue, New York NY 10010

ISBN: 978 1 84885 097 2

A full CIP record for this book is available from the British Library
A full CIP record is available from the Library of Congress

Library of Congress Catalog Card Number: available

Typeset in Plantin Light by Aptara Inc., New Delhi
Printed and bound in Great Britain by
CPI Antony Rowe, Chippenham, Wiltshire

FSC

Mixed Sources
Product group from well-managed
forests and other controlled sources
Cert no. SGS-COC-2953
www.fsc.org
© 1996 Forest Stewardship Council

. . . I present the composition as an art product alone . . .

Edgar Allan Poe

The author wishes to express her gratitude to Philippa Brewster for her support and Vit Hopley for her critical and encouraging comments.

Contents

To begin again

You, you who are persevering in being, awake to a question stuck in your throat. You want to have the question ejected, and you sit up straight to do so, but you cannot spit the words out and have them heard spoken. You cannot throw the question out of your mouth, and you cannot do so because the words themselves have not already been formed.

Putting into words can be a risky thing to do; nonetheless, you are prepared to take the risk, and you are prepared to do so because you have a hunch that doing so is bound up with life – living – itself. But now, in the present that is *this* morning, not a word is uttered. Your mouth is open but language is not, at least not yet, happening. Does the question, by lodging in the throat, presuppose the existence of language? Your voice keeps silent.

As yet you cannot say the question, and you cannot say it because the words are not there awaiting utterance, pronunciation, enunciation; however, the question is making itself felt and in doing so forces from you a small noise. It is almost a sigh, not quite a cry, but it is not the sound of a word: verbalisation is still not happening.

A question is making itself felt in the present that is this morning, and what is felt is the question's asking. The question

is asking and it is asking *you*. And in this asking what is moving through you is an interrogative sensation. What you, you and your voice, are being exposed to is interrogation: What can you say? But you say nothing.

So silent, silent there, where you are. A twofold silence: you neither, as yet, verbalise the question that is asking you nor, in response to its asking, say a word. And with this duplicated silence what you experience is unutterable powerlessness. *What can you say?* But you are saying nothing. And in saying nothing you experience a stillness the like of which you have never known before. But you are not petrified; you have not been turned into stone through fear, although it cannot be said that you are calm. You are not calm; for, with the silence and the speechlessness and the powerlessness there has come the feeling that you have been singularly thrown into question.

And there, in question, you are exposed to – and live – a time that you know not how to live. You live what seems to be the decisive time of a critical moment, the time when a decision is being made but as yet hasn't happened. It is an ordeal, but you, you who never have had a programme for the future, live it. And living it, living the silence of not a word spoken, your hearing wanders into your eyes and starts seeing. What do you see? What you see isn't something brought by sight. In fact, you are not even seeing something; for, what you are seeing is more than you can bear to see. What you are seeing is the limit of the liveable. It is an ordeal, but desire has not deserted you.

There is a question that, as yet, has not been put into words but which, nonetheless, has been insisting and asking you, although in response you have not said a word. The insistence of this unuttered question's asking has exposed you, you and your voice, to an interrogation – what can you say? But, so far, you do not say. Both voice and verbalisation have fallen silent and have become

exposed such that neither can be presupposed; yet this silence, in which you have found yourself unutterably powerless, makes the question of what you can say forcibly return. The silence and impotence has, somehow, forced you to think: What can you say? The question is asking something of you, yet it is also asking something of language. To ask what you are capable of saying is also to ask what language is capable of saying.

The question of what you (and language) can say is addressing *you*. You are being forced to think, and the thinking does feel personal. Yet the thinking is also felt as an impersonal force running through you. Could you be anyone? What can *you* say? You could be anyone, and you could be anyone because the question is valid for all, and this matters. It is valid for anyone, any verbalising being. However, the question isn't indifferent; in its address – to you – it is such that it matters that it is *you*. And it also matters that the thinking that is happening with you this morning, the thinking that is both personal and impersonal, is making it necessary for you to respond verbally to the question of what you can say. To think the question of what you, you and language, *anyone* and language, can say makes it necessary that you say, they say, something.

It has become necessary for you to say, and you want to say inasmuch as you want to say the question that has not yet had language happen. You, you who are no exception in having a proper name, want to say; however, you know that whatever does become said will not have been said by a verbalising voice that has been presupposed. And moreover, if the existence of voice and verbalisation cannot be presupposed before an utterance is made, then it cannot be assumed that, in responding to the question of what you can say, you will be speaking your mind. But the question is addressing you and in so doing asks for a personal endeavour that, whilst going with an

impersonal force, requires you to speak for yourself, in your own name.

To find out what you and language can say can only be found out by having you and language say. To know what you are capable of saying can only be known by enduring the interrogation that the question of what you can say brings. How can anyone tell, in advance, if they can endure it? What is required to endure it? Commitment? Critical activity? Desire? Just to be able, plain and simple? *What can you say?* The question calls for an interrogation; it insists. But has the question's call been born from interrogation by another; or, has it come from self-interrogation? Why should you be bothered to know this? What difference will it make knowing this? You are not indifferent to this question, yet it is only by way of finding out what you, you and language, can say, that you will be able to say.

To have had your voice and language's speaking become silent, to have been thrown into question and become exposed to an unutterable stillness and unliveable time, to have found yourself powerless, has enabled – yes, enabled – the question of what you can say to come. You cannot presuppose the existence of anything, but impotence is turning back on itself – you are experiencing thinking. And what you are experiencing here is not thinking of this or that but rather something of the order of potentiality – what *can* you say?

The question rings in your ear, and you cannot stop it. And that you cannot stop it makes you ask if, on this morning, this morning that will last god knows how long, *singularity* can be said. As yet you cannot say this word; you do not know how to say it.

What can you say?

It is asked of you that you say.

Opening

No one other than myself can respond to the question 'What can you say?' No one other than myself can say. I may not have wished for the question to have come but at least, with it, I do not stand accused. For sure, the question asks for interrogation of myself and language, and in so doing makes us inseparable, but it is not imputing blame. The question's inquiry has not come because of culpability; rather, it has come because a silence – speechlessness – made it such that a verbalising voice could not be taken for granted. Yes, the question came because a presupposition could not be made.

The question is asking me to find out what I am capable of saying, and there is no other way to find out than venturing to say. It would be the same for anybody. Anyone could be asked the question but it is *you*, you and language, that has to say.

To say what you can say requires that there is saying; it is unavoidable. You may think that you require some other – superior – voice to speak so as to say what you can say, but even for this voice there is still the matter of saying. You may think that you need to acquire an additional language so as to tell of what you and language can say, but even for this language, this metalanguage, there is still the matter of saying. Saying is

unavoidable. So, with the question of what you can say imploring you, you cross your fingers and pray that you can say.

What makes it so that utterances can happen? What makes it so that sticks and stones can be said? Indeed, what makes it so that I can tell you that I love you, that I can recount the words of a novel, a philosophical work or, indeed, the words of a woman who has said how difficult she finds it to live on such little money? I'll say it is the very thing itself indicated by a word, which is neither the concrete word itself nor the thing to which the word might be referring but that 'being said' has been rendered possible.

That 'being said' has been able to come into existence is not because someone has the ability to make a meaningful statement about this or that. Indeed, it is not about someone – me or you – being able to make an actual utterance, which perhaps breaks an awkward silence or helps a friend with a problem or communicates an intention or painful news. Rather, it is about language being able to make saying possible.

What I'm praying for is the very thing that makes anything whatsoever sayable. That 'being said' can come into being, that it can issue from my mouth, your mouth, anyone's mouth, is thanks to an ability that can 'make sayable'. And not knowing what qualifies me to say it, I'll say that language exists as this ability. Now, I could say that certain things in the world have sayability – they can be said. But what I'm trying to say here, and I'll admit there is tentativeness, is that sayability is the thing itself of language. To make sayable is what language *can* do.

What 'being said' first and foremost announces is not a flower blossoming beside a motorway but, rather, the existence of a mode that is simply that of being-in-language. Most of the time we pay no attention to this announcement or mode; nevertheless, with the flower blossoming beside the motorway there is, in being

said, an appearance in language, and what this appearance shows us, even if we ignore it, is that language *can* let appear. And first and foremost, this *can* refers not to the letting appear of this or that (the flower, the motorway) but, rather, appearing itself. And as for this appearance of appearing itself, I see it no other way: it is *only* opening.

What I am trying to say is that the 'can let appear' that appears and is announced with the mode of being-in-language is precisely what I have been calling 'sayability'. And to say this is to say that sayability is, in itself, nothing other than opening.

On this morning, my thinking is being held captive by the thought that sayability is the thing of, and the very taking-place of, language itself. And what is also holding me captive is the thought that this ability to make sayable doesn't in itself say anything. I cannot deny it – I am being forced to think. And what I am thinking of here is voicing without this being the voicing of something or somebody. What I am thinking of is the voice alone.

I say 'the voice alone' but by this I do not mean merely the sensuous sounds of vibrating vocal chords. The voice I am thinking of is soundless, and soundless in the sense that, although it is immanent in everything that is said, written or spoken, it doesn't say anything. This voice – alone – doesn't say anything, and it doesn't say anything for it is *only* opening. However, perhaps the word 'voice' brings with it a burden it cannot unload.[1] Perhaps the *only* opening that is holding my thought captive is better called 'revelation'.

What the mode of being-in-language immediately reveals is revelation. But, it has to be said, this revelation doesn't reveal this or that; for, what is revealed is revelation itself. Revelation in itself reveals no-thing; it reveals nothing that could be said to have hitherto stood behind it or before it. What revelation

itself reveals, and forgive me if this sounds obvious, is pure unconcealedness. Indeed, revelation itself, *pure* revelation, is nothing other than openness.

Pure revelation is in no way chaste, far from it; unremittingly, it is openness. And that, surely, deserves to be called passion: to reveal revelation itself is to reveal the '*passion* of revelation'.[2] And so, I now find myself saying that the thing itself of language is passion and irreducibly so. Truth be told, I find myself unable not to say that the ability to make sayable is language having passion – the *passion* of revelation. The passion is the openness that is revelation in itself.

I say 'the passion of revelation'. I could equally say that the passion of language is pure communication: what 'being said' first of all communicates, even if we choose to ignore it, is that language has the ability to make something communicable. Language is able to 'make communicable' and this *communicability* is nothing other than ability to be *only* opening, which is, precisely, the pure passion of communication itself.[3] However, being this passion, *having* this passion, doesn't as such make a communication that tells us about this or that state of the world or human affairs; in other words, nothing is communicated of gorgeous flowers or gory occurrences.

Now, the *only* opening that is the pure passion of communication or revelation may reject being figured as a soundless voice; nevertheless, it does present me with a 'communicative emptiness' in as much as with it nothing is actually said. And hearing the word 'emptiness' prompts me to ask: Are we only concerned to hear language say something, say something about something? But when we only hear language speaking about something – a gorgeous flower growing in the garden, a gory murder that has happened – what we ignore is the communicability and the being-in-language that is occurring. However, in attempting to

4

respond to the question 'What can you say?', which has come because a verbalising voice could not be taken for granted, the speaker here is finding it impossible to *not* not pay attention to the existence of communicability.

What becomes said to me and by me can be hurtful, as hurtful as sticks and stones hitting bones, yet on this morning I cannot help but see innocence in the openness that I'm thinking is the passion and taking-place of language itself. I say 'innocence' and I mean this in the sense of an open face that is before you and hiding nothing whatsoever. Perhaps the innocence of an open face brings too much of the infant with it, yet let's not forget that in Latin *infans* is precisely that which is unspeaking. To see in the word that which is an open face is to see that which is *only* opening; indeed, it is to see a communicative emptiness where, akin to the infant, meaningful discourse is not yet spoken. But is this open face, this communicative emptiness, more than we can bear to see?

Why should I ask this? On this morning I am held captive by the thought that the taking-place of communicability is the taking-place of language, and in trying to find out what I am capable of saying I am finding that the taking-place of language is what, most of the time, we presuppose. And hearing these words said begs the question: What is happening when, in speaking or writing, the taking-place of language is presupposed?

All sorts of things are said in our world – horrible things, flattering things, informative things – and that such things can be said is, at least for me, thanks to communicability taking-place and language giving itself. However, it can so happen, and does happen, that this giving is taken, and taken in the sense of an acceptance that it – the taking-place of language – has already happened. For sure, such an acceptance may be unwittingly made yet what happens with it is that the giving is transformed into a

given. And when the taking-place of language is taken as given it is not only taken for granted, which is when you would say 'it goes without saying', but also taken as having already happened. Indeed, in being taken as given, the taking-place of language slides into not only an antecedent position but also a sup-position. And what happens here is that the taking-place of language sinks into the form of a presupposition: it goes down to a place beneath and there, beneath, becomes covered. In short, language's open face – the passion of revelation – ceases to be seen.

Obliteration

When presupposition takes hold what becomes established is not only a *before* but also a *beneath*. With presupposition there is the *pre*, which establishes anteriority and antecedence, and then there is the *sup-position*, which installs a realm that is underneath, beneath or, in other words, hidden below. Through establishing anteriority and antecedence, presupposition leads me to believe that something is already there and, as such, can be taken as given. Presupposition gives me a before in time, which as it were 'goes without saying'; however, it also puts into position a realm beneath that remains hidden from me.

Two people are speaking. They are talking about this and that. *What a lovely day. That was a kind thing she did.* Yes, they are happily nattering away (no argument on this occasion); but, is their experience of language one of presupposition?

An awkward silence is just about to be broken; a novel is just about to be written; an accusation is just about to be made; a declaration of intent is on her lips – and in advance of a word being spoken, or written, has it been presupposed that language *is*? How can we speak without making such a presupposition? Would I be able to speak? Would *you*? How can we speak without presupposition?

How can we speak without presupposition? Is this the question that I have been unable to spit from my mouth and which brought forth the asking of what I can say? Truth be told, I cannot say. But I do have a hunch that the question of how to speak without presupposition will not go away.

With the question 'What can you say?' there has come the matter of language being able to 'make sayable' – should I be surprised by this? Perhaps the matter of sayability is precisely what the question is asking me not to overlook. Should I be surprised that I have found myself thinking of sayability – or, in other words, communicability – as the very thing of, the very taking-place of, language itself? Indeed, that the question came because speech fell powerless does make me wonder if the question is begging me to see that, in responding to it, the taking-place of language hasn't already happened but is, in whatever I say, happening there and then. Which is to say, happening *now*.

So, I am wondering if the question 'What can you say?' is wanting me to experience not some language content but, rather, the very speaking of speaking. Is the question wanting me to 'undergo an experience with language'[1]? Is it wanting me to undergo an experience with language other than gathering or promulgating information about it? Is the question, which could be asked of anyone, wanting to have the very taking-place of language to be experienced without presupposition?

– What can you say?

And for a moment the question silences you. You don't know what to say. You cannot say. But the question insists. It returns. And you start saying. A silence so huge had grabbed you by the throat and roared in your ears, but in that silence language touched you with what it can do: language can give

8

communicability, which is what puts us in contact with mute things and constitutes the event of language. And for a moment so fleeting that it is almost gone before it arrives, you speak without presupposing the existence of language. And in this instance, so brief but nonetheless glorious, there appears before you an absolutely exposed – open – face. And for once, the taking-place of language has morning and arises without obscurity.

If the taking-place of language ceased to be presupposed it would not, so to speak, 'go without saying'. But hearing these words said brings a question I hardly know how to ask: How can that which doesn't say or communicate anything come to say itself? Facing this question, I am unsure as to what to say. I cannot say. But what I can say is that communicability is not a 'something'; it is merely an ability, a capacity – a *passion* – to communicate or signify. Communicability doesn't communicate or signify anything, but it is the very thing by which an actual communication becomes possible; without it there would be no 'being said', no meaningful discourse or, as some would say, linguistic signification. Communicability is not a something, yet it is precisely that which gives me a way to tell you about a flower that, blossoming besides a motorway, caught my eye. (Do you want to hear that? Does it interest you? Or would you rather hear of a murder that never needed to happen?)

Communicability makes communication possible; however, as soon as something is actually said, and meaningful discourse takes place, it becomes the very thing that is obliterated. Even though meaning is never a straightforward matter, even though there is wavering in the way words signify, what happens when an actual communication happens is that language's open face comes to refer to something that is external to it and we are granted (no matter how precarious it might be) meaningful discourse.[2] Language – *lingua* – is now saying something. And now it is a

matter of what is said — *Do you know what he said?* — *He didn't say that, surely!* The tongue is wagging and language's open face falls silently into oblivion.

It would seem there is a lack of way for communicability to say itself in that which it grants. How on earth can a 'communicative emptiness' *not* go without saying? For sure, the wagging tongue can speak about it, but, in so doing, it will have been turned into a something about which something is being said. In short, it will have become an object of communication. For communicability to be spoken of in actual discourse it takes on the form of a something, but becoming such a something it yet again becomes erased. Or to put it another way, the event of language, which is happening now, doesn't say itself when I — and language — speak about it, which is precisely what is happening now.

So, there is a lack of way (or, at least, so it seems) for actual discourse to say the very event — communicability — that makes it possible; but, hearing these words said, a question comes howling: Is there no other way than that of deeming language's open face to be unsayable? I acknowledge the 'lack of way', the aporia as some would say, but with this acknowledgement am I to simply accept that language's open face is *un*speakable and that as such there is no other option than to presuppose it? Would you find happiness in having communicability placed in the realm of presupposition and, at the same time, abandoned? (Would you find happiness in having a communicative emptiness bear a negativity?)

Take 3

Division

On this morning that will last god knows how long, I have been unable to ignore what 'being said' first of all announces, which is not a flower blossoming beside a motorway but, rather, being-in-language. With my hearing wandering into my eyes, what I have been unable to overlook is language's open face. For a moment this face was conspicuous, and I could not look away. For a moment so brief, but which seemed so long, I saw a communicative emptiness. For sure, this emptiness gave nothing to say, but a terror was not struck in my heart; for, with this emptiness what I saw was the appearing of appearing itself. And what I also saw was how meaningful discourse had come to presuppose and abandon this appearance because the communicative emptiness was quite simply, for it, unspeakable. And seeing the word's open face left 'so abandoned to itself' I found myself wondering what I could say.[1]

— *What can you say?*

I would be the first to admit that I could be going round in circles; nonetheless, I'll hazard to say that because the taking-place

of language – communicability – is presupposed by meaningful discourse is why, for meaningful discourse, it remains *unspeakable*.

Let me put it like this. Once the mechanism of presupposition cuts in, the taking-place of language is assumed to have already happened before the utterance of meaningful discourse and, moreover, goes to a place beneath, which is to say, 'goes to ground'. And when the taking-place of language is put in the position of both *before* and *beneath* it becomes placed *beyond* meaningful discourse. In other words: 'the event of language always already transcends what is said in this event'.[2] And what is more, when the 'event' (the taking-place) of language is placed in such a transcendent position, language is at once torn apart; indeed, language suffers a scission that divides it into two separate realms: on the one hand, the taking-place of language; and, on the other, meaningful discourse, which corresponds to the realm of the 'said'.[3]

On this morning I cannot say that the division of language into separate realms hasn't penetrated my attempt to find out what I can say; nonetheless, I have been forced to see that, once presupposition occurs, what I have called 'language's open face' becomes excluded from the *parole* of meaningful discourse.[4]

Presupposition happens and, at the same time, exclusion happens; and with this happening a darkness inheres in language: the 'communicative emptiness' of language's open face becomes a negative silence as the taking-place of language goes to ground, becomes hidden and takes on the form of a secret.

Perhaps it is a simplification to say that presupposition cuts language into two separate realms. Perhaps presupposition is sending me round in circles. However, what I can say, what I can *not* not stop saying, is that presupposition makes the open face of language go to ground and, in so doing, go to the hidden place where secrets are kept. But what brings a joy to

me is that although language's open face takes on the form of a secret, the secret itself does not guard or hide anything. The secret has nothing to reveal. It is anything but a secret; it is nothing other than openness, the pure appearing of appearing itself.

With the appearance of appearing itself there doesn't come the appearance of this or that (a flower, a motorway). There doesn't come the appearance of something that hitherto had been hidden or concealed and required a darkness to be dispelled. On the contrary, what appears is an appearance *beneath* which or *behind* which there is absolutely nothing hidden; it is, passionately and gloriously, pure revelation. Perhaps it is a sight for sore eyes; for, here there isn't something to see. There isn't a finely wrought picture to see. What there is to see is an empty image, and if you patiently dwell in this emptiness, you will see that this image isn't a representation of nothing.

In responding to the question 'What can you say?' I have found myself speaking of the event of language. And although it may have been said between the lines, what I have found myself saying is that the event of language is irreducible to either determinate meaning (what is said) or the material word. Why say this word event?

An event is the occurrence of something, its very taking-place, yet I must say that in going to grasp the *event* of this event what I have found is that I am not grasping a 'something'. For sure, my habits of thinking can lead me to believe that there is (a) something that is taking place, but if for a moment I break a habit and consider not a something but only the pure event of the taking-place what I will find is that the event itself is somewhat of an incorporeal entity. For me, this not-being-a-something is what is crucial to the *event* of an event.[5] This event is not a thing, but it is not nothing.

For me, at least on this morning, the event of language is most certainly the taking-place of language; yet I have to ask: Is this the taking-place of something? I have been held captive by the thought that the taking-place of language is the occurrence of what I have been calling 'sayability', 'communicability', 'the pure passion of revelation or communication', '*only* opening' and, *licentia vatum*, 'language's open face'; and why I say 'event' is because the occurrence that all these words are attempting to name, which I am also saying is the very thing itself of language, isn't the occurrence of (a) something. The event and thing itself of language may not be a something but it is not next to nothing, although it has to be said that most of the time it remains in the dark for us. On this morning it seems that the question 'What can you say?' is forcing me to see this darkness. I cannot look away.

Appearance

In attempting to find out what I can say, I have found myself being forced to think of and say things with respect to language. I'll not deny the worry of oversimplification or overcomplication, yet the wonder is that I *can* say. And that I can say is exactly what is forcing me to think of and say things with respect to language. I cannot think it any other way: it is thanks to language's ability to make sayable that I can say. For me, on this morning, it feels as if the taking-place of my being is inextricably linked to the being of language. And saying *being*, I'm stressing the verbal rather than the substantive dimension.

I am not sure what qualifies me to say this, but I'll say it nonetheless. To stress *being* as verb rather noun is, at bottom, to say that being is only ever to be found in its taking-place; it is to say that being is an incessant emergence. However, when the taking-place of being is presupposed it slips into an antecedent position and, at the same time, sinks down to a place beneath. And when that happens, my being or your being or indeed language's being comes to remain below itself. And (a) being that remains below itself is (a) being that does come to itself in its taking-place; it is (a) being deprived of the felicitous experience of enjoying its taking-place. But when presupposition does not hold sway

there comes the chance to enjoy our being. What we enjoy and find good is the 'coming of the place to itself'.[1] When nothing of our being remains behind or below us, we go only towards taking-place and are *only* our taking-place, which is to say that we *appear* without remainder.

This morning my thinking is being held captive by a vision of language, and held captive means that the vision is insistently, stubbornly, beckoning me to see it. It keeps appearing to me, and *it* is language's open face. Each time this open face is about to fall into obscurity the vision comes. On this morning, I have the feeling that the question 'What can you say?' is forcing me to become a seer.

With the vision of language that keeps appearing to me, I see the appearance of appearing itself, which is to see appearance coming to its own taking-place. With this appearance, what is not seen is the appearance of 'it seems so', which suggests that what is seen could be otherwise, could be a deception. Indeed, seeing the appearance of appearing itself, I do not see an appearance that is like a mask and separable from something that remains, in the shadows, behind it. What is seen is sheer appearance – 'a pure, absolute visibility, without shadow'. And here is appearance without latency, remainder or residue. Which is to say, further explication is not required. Thus I can say: 'it shines, it stands out in its evidence.'[2] Here it is: appearing absolutely exposed. In other words, pure exteriority. And that is *only* a face. Not a face that acts as a front; on the contrary, nothing other than an open face. That is to say, a face shining in its appearance.

I am not ashamed to say this. There is happiness in appearance shining in its own appearance because, for once, appearance is appearing without being burdened with any pejorative meaning; indeed, for once, it is appearing without the burden of being a bad thing. And without this burden, the appearance of appearing

has the chance to take pleasure in being a free spirit, by which I mean, it has the chance to grasp its own taking-place and, in grasping it, enjoy it.

On this morning, I have seen an appearance that is without shadow. Albeit in brief moments, I have seen appearing coming to its taking-place. And for me, this very movement, of coming to and going towards taking-place, constitutes what I can only call an event. And why I say 'event' is because with such movement there is nothing behind or before that would explain or reveal it further or stand as its beginning or foundation or, moreover, act as its external cause. Indeed, if we make the time to patiently dwell in the 'empty image' of communicability, what will be seen is that language is ungrounded or, to put it another way, has no foundation except in its own taking-place. However, once the mechanism of presupposition cuts in this vision will be concealed from us and become a miserable secret.

I am told that some things are best left unsaid. Be silent. Sssh. Stay stumm. And why it is better to stay silent is because if what were to be said was said there would be consequences that would harm another or indeed yourself. Some things are best left unsaid because the blow that would be delivered in saying such things would be too much to bear. *She would have to suffer yet another beating. I'll be killed for saying that!* And so you stay silent and hush your wagging tongue. But is this silence in any way similar to the silence that is enforced as language is split apart and the taking-place of language becomes the opposite of the utterances of meaningful discourse?

When the taking-place of language 'goes to ground' and becomes that which 'has been', a scission forces the taking-place of language to dwell separately from the domain of meaningful discourse. From now on the taking-place of language becomes unsayable and is, in effect, excluded from meaningful discourse

and left abandoned to itself. However, this is not the end of the story; for, this exclusion serves to provide the fiction of a foundation (that which has 'gone to ground') and a beginning (that which 'has been'); but this exclusion and fiction also keep in the dark, and so leave 'best left unsaid', that language is ungrounded. On this morning, the question 'What can you say?' is forcing me to see this darkness. But it is also beckoning me to see a felicitous vision, and I cannot look away. Indeed, I cannot look away as I see a vision of language with which comes an appearance and a movement that enjoys its taking-place without anything whatsoever hidden behind it or below it.

Who knows, maybe I am being beckoned to see such a vision so that, in seeing it, I myself enjoy and gain happiness from another's coming to its taking-place, which in many respects is to gain awareness of the pleasure and happiness to be had in my incessant emergence, that is to say, my taking-place and *being*.

On this morning I have seen a vision where happiness arises from a founding process that hasn't 'gone to ground' but rather takes place without presupposition and shines in its appearance. And I cannot help but think that what is at stake with such happiness has something to do with politics. Would it be best if this was left unsaid? Am I to be beaten for saying such a thing? Am I to be mocked? In spite of that, what I cannot leave unsaid is that the communicative emptiness – the empty image – that lies at the heart of the event of language *is not* the silence of meaningful discourse. For sure, with language's open face – the pure passion of revelation – nothing is revealed save for revelation itself, yet I do not want to take it as given that this revelation that is empty of an actual linguistic content is the opposite of, the lack of, signifying speech or meaningful discourse. I cannot deny the perplexing matter of having the event of language say itself, yet I do not want to leave this event as that which is best left unsaid.

APPEARANCE

— What can you say?

The question returns and brings with it the imperative of saying — say on! And saying on what I will say is that now I cannot overlook and ignore presupposition. However, there still remains the issue of how, in speaking in my own name, I can say, myself and language can say, can say on this morning that will last for god knows how long, singularity.

Movement

How am I to say singularity? I can say the word, that is not hard to do; but how can I say it such that it is not a meaningless sound?

How am I to say singularity? Is this the question that, on this morning, I have been unable to throw from my mouth? I have to say again that as yet I cannot say, which leaves me no option than to ask: How am I to say what is proper to singularity? What can I say? But asking this question leaves me asking: Who am I to say what is proper to singularity?

Who am I to say? For me, at least on this morning, what is in this question is not an expression of self-deprecation, which could be a false modesty, but rather a worry over the issue of authority. What would qualify me to say what is proper to singularity? Can I, off my own back, just forward a claim? Can I be such an author? Perhaps from my pen fine words would be wrought, but can I, even for the fine wordsmithery, make a claim that arrogates to itself? How am I to appease the worry of inciting misunderstanding or ill saying or, indeed, talking out of the back of my neck? Would appeasement come by submitting my claim to an authority that would examine, judge and authorise and say it is, or not, okay? However, the question 'What

can you say?' asks you something quite other than 'Who am I to say?' What it asks is a question not of authority but rather capability.

The question 'What can you say?' brings with it the verb 'can' and what this verb means is 'to be capable', which asks that we bear not the worry over authority, which in the end sends you round in circles, but rather the more demanding experience – 'perhaps the hardest and bitterest experience possible' – of potentiality.[1] And why 'to be capable' is so demanding is that it asks for the acknowledgement that potentiality can 'both be and not be, for the same is potential both to be and not to be'.[2] To bear the experience of potentiality, which the question 'What can you say?' is demanding, is for you – for anyone – to live knowing that to be capable is also to be capable of incapability, to not be able – every potential to say or do is equally a potential not to say or do. Indeed, to say 'I can' – 'I can say' – is to bear an experience that faces you with impotentiality: 'I am capable of not being capable of saying'.

I am capable of not being capable of saying what is proper to singularity – would you buy tickets to hear that? Wouldn't the preference be to hear the violinist playing? Wouldn't the preference be to hear someone saying that they have something to say with respect to saying what is proper to singularity?

And someone arrives who does have something to say, and you want to listen. They start saying and you start listening, and what you hear is twofold: you hear 'that about which' someone is speaking, which is so named singularity, and you hear also decisions of character – determinations and judgements – that the same someone is saying of it. Let's say that a hitherto meaningless sound – singularity – is achieving meaning as it becomes the subject of a predicative assertion. Someone is saying something about something, and so too is language.

The language that was handed down to me as I was entreated to grow up and leave infancy behind ceaselessly asks me to handle a subject and predicate relation. The language I have to hand keeps on saying that first of all there is the subject – let's say 'morning' – and then, secondly, the words by which something is said of it – 'brings daylight'. Behold: 'Morning brings daylight'. Perhaps these words are not making a politically important statement but at least with them something is being said.

As I left infancy behind my education insisted upon and persisted in teaching me the importance of saying something. Stand up and say something about something! And as I diligently did, I learned to make predicative assertions; but what no one told me was that in learning to say something about something I was also learning to make presuppositions. In order to say 'brings daylight', and for these words to be meaningful, I had to take 'morning' as already given; if I did not presuppose it then I could never have accomplished saying something about it. What my education handed down to me was presupposition. As that child how could I not presuppose? Now, I could have stood up and just said 'brings daylight' or indeed 'remains suspended', but what was said to me, on 'good authority', was that language must speak about something. For sure, I could have stood up and said 'morning' over and over again, but that would not have sufficed; for, my education was insisting that I must do more than merely say or repeat names. Indeed, my education insisted that I must not be infantile and, moreover, that the word 'must communicate *something* (other than itself)'.[3]

As soon as singularity appears in language as that about which something is being said, singularity – or indeed morning – becomes spoken of on the basis of a presupposition, which is to say that it has become the subject that is taken as given before a word is said about it. For sure, singularity has become a subject

about which something is being said, and this could be politically important, yet in becoming the subject of a predicative assertion 'singularity' bears the burden of presupposition. So as to 'say something about' I am asked to presuppose that there is something of which something is going to be said, and what all too quickly happens here is that singularity becomes a *something* that occupies not only a position of antecedence but also sup-position or, in other words, sub-stance.

(The subject–predicate relation makes me presuppose something in order to bring it into the light of day and say something about it, and with such presupposition I am led to believe that something is beyond language. Indeed, what is brought to me is a vision of something that not only precedes language but also remains beyond it. And what this vision is successful in doing is making me believe that language is communicating *something* other than itself.)

In making predicative assertions, you are most certainly put in the position of finding out what you can say about something; however, on this morning, I am finding myself delaying in presupposing 'singularity' in order to say something of it. Think me infantile but I'm dragging my feet in presupposing that singularity is (a) something that can be presupposed. My question may be ill-formed but I'll ask it nonetheless: Can singularity only appear when presupposition doesn't appear? If this is the case then how on earth is singularity to appear in language? If I do say that singularity can only appear on the basis of no presupposition do I not run the risk of rendering both singularity and myself mute? Perhaps I do, but what I want to ask is: How can I say something without presupposing that about which I speak?

— *How can I speak without presupposition?*

24

Indeed, the question hasn't gone away.

On this morning that will last for god knows how long I am finding that I cannot stop thinking of presupposition, yet I am also finding that I cannot stop thinking of – seeing – that which is only going towards and only *is* its taking-place and which, as such, constitutes an appearance and movement – an *incessant* movement – that isn't an 'effect of' something (a cause, an essence) that remains beyond it. And with a movement such as this, which is a movement that is absolutely exposed, it is possible that singularity appears.

TAKE 6

Names

Why should I be bothered by the question of how I can say singularity? Truth be told, I do not know the reason, but I am bothered. All that I can say is that there is the hope that, staying with the bother, the whyever of it will become apparent. For all the bother, however, I cannot help but think that to appear without residue, remainder or reserve is what is proper to singularity.

On this morning I have been held captive by the thought that singularity pertains not to some (one) separate and individual thing but, rather, *being* that is only ever found in the movement of its taking-place. Which is to say that with singularity *being* is a movement that goes only towards its taking-place, and this is to stress being in its verbal rather than substantive dimension.

The being that is nothing other than the movement of its taking-place does not hold on to existence as a property; more-over, without anything whatsoever remaining beyond its taking-place, it is not master of its own being. But it does make free use of itself — its taking-place is the incessant engendering of itself. Singularity: an *ethos*, a way of being.[1] To appear without residue, remainder or reserve means that you — or whatever — has the chance to enjoy an appearance that does not arise on the

basis of presupposition. In other words, you are internally, as singularity, pure exteriority. *You* are shining, and it is beautiful to see.

In such shining you are a free spirit, yet it has to be said that becoming a free spirit, which is when you make free use of yourself, is not simply about having and exerting a power to do this or that. Indeed, becoming a free spirit is not about playing some identity game where it is believed that one appearance, mask or manner can be dropped or swapped for another; on the contrary, it is to become an appearance that has nothing whatsoever hidden behind or below it, that is to say, an appearance that is utterly 'as it is'. The free spirit strives to (and desires to) go towards its taking-place, and with this movement it becomes impossible to make a distinction between the active agent that engenders and the patient that passively undergoes such 'self' generation. Singularity: the free spirit where agent and patient cannot be told apart.

Embracing singularity as that which is 'as it is', you would not say that here is a subject that is found in this or that mode; for, this would instate an initial or primary something or someone that remains latent and which could be otherwise than the mode in which it is currently appearing. Rather, it would be to embrace an appearance that shows itself without reserve. Shameless, you might say. But for me, at least on this morning, this 'without reserve' is what makes the appearance, the *being*, lovable. When we love, it is not a particular quality of the loved one that makes us fall and holds us there but rather the loved one such as it is – I would not want her or him or it any other way.[2]

Singularity is the lovable for it gives to the world the loved one that you would not want any other way. *You* are shining, and you are lovable. You are a free spirit, but to be as such is not simply to possess a power to be this or that; it is, rather, to be capable of your impotentiality.

On this morning I have been trying to find out how I can say singularity, and what has been beckoning me is the thought that singularity only appears when presupposition doesn't hold sway. However, to say that singularity never takes place on the basis of presupposition does leave me again asking: How is singularity to appear in language when the subject–predicate relation keeps forcing me to say singularity as the presupposed subject of a predicative assertion? I could refuse to make any predicative assertion and merely utter 'singularity' over and over again. But if I were to say the word a thousand times over how long would it be before I was interrupted by the demand to say something more than merely a name? I am convinced that it would not be long coming. And what would be demanded of me is that I speak those words by which something is said about something. However, for these discoursing and predicative words to be meaningful, I am told that the existence of a name has to be presupposed – a predicative assertion only becomes possible through taking a name as given.

 – Can I speak without presupposing the existence of names?

Some would say that the infantile vocation of language is to name and, moreover, that naming reveals language's openness to a world.[3] And there you are for the first time finding yourself in a world and naming. And you delight in saying the word that names. And you are delighted because in naming you are receiving the world and, in effect, saying 'yes!' to it. You are easy as you say the word morning and you are easy as you say other names. And you are easy saying names because what is named is *in* communication with you – it is exposing itself to you. If it were not, you would never be able to name. You are naming but nothing is being communicated through language; for, here

the word, the word that names, has not (yet) fallen under the demand that it must communicate *something* (other than itself).[4] The named is not communicating itself *through* the word; it is, rather, communicating itself *in* the word. You are naming, but in so doing you are not presupposing the existence of something 'non-linguistic' beyond language. Indeed, in naming what you are experiencing is linguistic being. And what delights you with this experience is that the named is making its being-language communicable to you. And for you there is nothing mysterious about this. For sure, it is magical that linguistic being is being communicated to you, but this does not mean that the name-word is magically the very essence of 'it' that is named. And nor does it mean that the nameless have suddenly discovered tongues and are speaking words to you. For you, *you* that infant in language, that would be a stupid idea.

You are naming and experiencing linguistic being. And you embrace it. And you play with it. And you are delighted. And you are delighted because you are discovering that the name-giving gesture is an experiment with language. But then (it seems so sudden) the insistence comes that you begin to say something about something. And now you become the child who in encountering the world has, beyond names, something to say of it. And as you become that child, and enter the world of discourse, you are instructed that names are what you receive. Quite simply, you are to learn names and, moreover, learn that names are what are handed down to you — it is an historical transmission. From now on names are what precede you. For language and yourself to speak about something the existence of names must be presupposed.

As you learn to say more and more things, you find out that discourse always predicates something of something whereas the name tells you nothing about that which it calls — the name only

makes an announcement and asserts nothing. Indeed, as you learn more names you find out that the meaning of a name has to be explained – passed on – for you to understand it. And then you find out that for discourse there is something unsayable with the name; it cannot say what the name names. And then you are told that this is why, for discourse, the name and the named can only be presupposed. And here, as presupposition tightens its grip, what emerges (again) is a fracture of language itself. A split has occurred: the name and discourse occupy realms that are separate from each other. For sure, names can enter into the world of propositions and statements, but what is said in this discourse can only be said 'thanks to the presupposition of names'.[5]

– How can I speak without presupposing the existence of names?

Discourse presupposes names and, what is more, presupposes what is named by the name. Discourse cannot say what is named by the name; it can only predicate something of it. The only way for the named to enter language is through presupposition; indeed, the named can enter language only on the condition that it becomes a subject – a name – that has been presupposed by the words that say something of it. Discourse presupposes the name 'morning' in order to say something of it and what is named by the name is also posited on the basis of a presupposition, which sets the scene for taking as given that the named occupies a realm that is anterior to and beneath language. I cannot deny it, the presupposition of the named is successful in setting the scene for a vision of something that is, in all senses of the word, *beyond* language.

The words that predicate something of morning most certainly bring morning into the light of day; however, through

presupposition, this morning will be banished to a realm that is separate from – *behind* – and dark to – *beneath* – the world of discoursing words. Through presupposition what is named by the name is brought into discoursing language, but as this happens it is also excluded from it.

The language of discourse asks me to take as given that something is there prior to the advent of the words that speak about it. And in asking for the acceptance of this given what is produced is a world of 'somethings' that are a world of something-other-than-language. And what there is to experience here is a division that divides the non-linguistic from the linguistic and, accordingly, separates the taking-place of things in the world from the taking-place of the word. A division is made and with it comes a vision of something that stands outside of language. Behold morning, but beholding it through presupposition is to see a vision of some non-linguistic thing that has been included in language only on the condition that it has been excluded from it. And seeing this vision, on this morning, leaves me saying that, in truth, such a non-linguistic thing is something that only can be conceived of in language. The non-linguistic can only ever be found in language; it is what is presupposed in the name. The non-linguistic is 'nothing other than a presupposition of language'.[6]

In responding to the question 'What can you say?' I am trying to find out what I can say; but is this question asking me to presuppose the existence of the name and the named? Or is it wanting me to see how presupposition produces and maintains an anterior realm and, equally, a realm that is underneath? And I ask this for in responding to the question 'What can you say?' I keep catching presupposition in the act of bringing about these realms. Moreover, I keep seeing how presupposition acts to conceal.

I go to speak about something but before a word is said I am told that discoursing words have to presuppose not only the existence of the name but also the named; and what this double presupposition produces, for discourse, is that which *has been* (a beginning) and that which *has gone to ground* (a foundation). Indeed, the presupposition of the named that occurs in the name produces a position that is outside of the linguistic yet, in being anterior and beneath, provides for it a beginning and foundation – a ground – that is non-linguistic. However, what this presupposition serves to conceal is that discourse and name – the linguistic – are groundless. I can *not* not say this: to expose the double presupposition of the name and the named is to expose groundlessness. And if presupposition is not to send us round in circles by making us believe that with such an exposure we have actually lost something then the need must be, surely, to think this groundlessness without any negativity. Can I do that? Can I?

How am I to think the groundlessness of the linguistic without negativity? Is this the question that made a verbalising voice fall silent on this morning? Is this the question that I have been unable to spit from my mouth? Again I have to say that as yet I cannot say. But I do wonder if in embracing the groundlessness of the linguistic there is a chance to experience a world that does not suffer a division between the linguistic and the non-linguistic. Perhaps I dream, but I do wonder the consequences of having the presupposition of the non-linguistic exposed.

And for a moment I do see what is named by the name appearing not in the form of its presupposition but, rather, its exposure; and with this I see the taking-place of things in the world as no longer separated from but in the midst of their appearance in language. What I see is an appearance

in language that has nothing non-linguistic remaining beyond it.

And then again the question returns — *What can you say?*

Is this question asking for critical activity? Or is it simply asking me to continue and endure the interrogation that comes with it?

Happiness

Why would someone persevere with the question 'What can you say?' On this morning I can think only of one answer: because they desire to do so. To persevere in finding out what you can say asks for a striving, and such striving is inextricably linked to the desire to do so. In other words, striving and desire go hand in hand.[1] To persevere is to desire to keep going, which is to say that (your) perseverance is nothing other than the movement of desire itself. Perseverance is the desire to keep going; it is, also, the desire for desire to keep going. And for the movement of desire to keep going it is required that desire incessantly constitutes itself as desiring, and what happens here is an action – *desire* – that refers to the agent – *desire* – itself. What also happens is that desire becomes both the agent (*the one who acts*) and the patient (*the one who is acted upon*).

In continually desiring itself, desire incessantly acts upon itself such that the agent (*activity*) and the patient (*passivity*) cannot be told apart. And when agent and patient cannot be told apart, desire becomes its own *immanent* cause; it becomes nothing other than a self-constituting movement.[2] And when the movement of desire does not leave itself and goes only towards its taking-place, desire can 'rejoice' in itself – it lacks nothing.[3]

I cannot help but ask if the question 'What can you say?' is insisting upon my perseverance so that I experience (my) desire enjoying its own taking place.[4] If this is the case then persevering with the question would be my effort to experience the enjoyment of constituting myself as desiring.

What can you say? Do you desire this question once more and innumerable times more? Yes, I do.[5] In saying 'I do', I am most certainly saying yes to desire and striving going hand in hand, and I am also saying yes to a movement of desire that incessantly constitutes itself as desiring. To say yes to this movement, which cannot stop if desire is to continue desiring, is to say yes to an existence that doesn't rest upon a foundation that remains prior to it or hidden below. It is to say yes to an existence that hasn't been determined by nor caused or founded by something that remains external (that is to say, withdrawn) from it. And what has been glimpsed this morning is that whatever comes to exist in this manner is that which brings happiness to the world. What is happiness if not an activity that has nothing hidden or withdrawn from it?

So often we say yes to something for the sake of something else – *I'll do it because of* . . . But with happiness there is no such because. We say yes to happiness for its own sake, which is to say that happiness is its own because. Happiness appears by the cause of nothing other than itself; it is 'self-sufficient'.[6]

Hearing these words said prompts me to say that what brings 'happy life' to the world is a manner of rising forth that doesn't presuppose itself, doesn't remain below itself but, rather, appears without reserve and stubbornly remains immanent to itself.

How am I to live a happy life? Is this the question that stuck in my throat? Is this the question that rendered me speechless, powerless and incapable? Is it? I still cannot say. But what I can say is that in attempting to find out what I *can* say, which is not

the same as saying what I *want* to say, I am finding myself drawn to speaking of happiness. But does such (happy) talk mean that the activity of critical thinking has become stilled? However, raising this question does ask me to question the presuppositions I hold concerning what it is to be critical. And perhaps such questioning is exactly what critical activity demands: to not take anything as given, to not presuppose. If this is so then I cannot presuppose that critical activity involves either being resolutely against something – *I protest!* – or moaning about the way things are.

I would be the first to admit that I moan, and some days I can go on and on . . . so full of complaint. I will moan about the circumstances of my life. I will moan about this and I will moan about that. And, moreover, I'll join in with those who moan silently as they say 'mustn't grumble'. Am I to criticise the moaner in me? Am I about to deliver an opinionated argument against moaning? But would this constitute critical activity – would it constitute *critique*?[7] This is a demanding question.

To be against something is perhaps what some would deem critical activity to be all about. Such an activity may well endeavour to identify and challenge something that oppresses (. . . *know your enemy*), yet what happens here is that which we are against becomes taken as given. However, to take the criticised as given – to presuppose its presence before a word is said against it – is to leave it unquestioned. For sure, questions may be asked of it but, in itself, it remains unquestioned. And to be left unquestioned allows not only the criticised to take itself for granted but also indifference to breed.

Indifference arises when we can't be bothered to ask questions and become tired of living and thinking; and indifference finds a breeding ground when criticism becomes the activity of making a claim about something as a counter-claim to another claim. As the

claims and counter-claims go to and fro what soon only matters is the battle between the claims and when only this matters each claim is not concerned with, becomes indifferent to, calling into question the presuppositions of its claim. And as the claims and counter-claims go on and on and the criticism becomes endless (*oh listen to the politicians*) there comes a point when you shrug your shoulders and say: who gives a damn! And these words are the words of indifference.

The activity of 'being critical' has to question everything; it cannot be indifferent. It cannot take the criticised as given; it cannot take the critic as given; and, moreover, it cannot take itself as given. In other words, it has to be total, which is to say that no stone can be left unturned.[8]

Hearing these words said makes me hesitate and wobble before saying anything; they make me want to cry out: What can I say, what can I say? The one thing, however, that I can say is that if critical activity is to take place it cannot be for the sake of something else. It cannot be 'I'll do it because of . . . ', which would mean that critical activity is put in the service of something that lies beyond it and escapes its activity. Again, it is a matter of no stone being left unturned. But embracing what is said here takes me – and critical activity – to an 'extreme place'.[9] And it is an extreme place; for in taking-place the activity of being critical has to bear the radical insecurity of questioning everything, including itself and any 'cause' that lies beyond it.

Critical activity cannot take place for the sake of something else; it can only go towards its taking-place, yet in this move-ment it has to bear the insecurity of taking-place without self-presupposition. Nonetheless, in bearing this insecurity critical activity has the chance to become its own immanent cause. It has the chance to grasp its own because and to become an appear-ance that has nothing whatsoever hidden behind or below it. I'll

risk saying, on this morning, that happiness does not mean the cessation of critical activity.

What is demanded of critical activity – what it demands of itself – is that it bears the insecurity of taking-place without presupposing the criticised and, moreover, itself. For sure, this demand requires perseverance in unearthing and exposing presupposition, yet with such perseverance we do not give up our desire; for, desire and perseverance go hand in hand.

So much in our lives makes us want to give up on our desire. We become tired of living and can't be bothered to persevere, and that we can't be bothered means that indifference holds us and we cease desiring our desire. I would be the first to admit that persevering in unearthing and exposing presupposition, particularly self-presupposition, can be daunting and simply too much. *Why bother?* But if I do bother and care to persevere with critical activity and bear the radical insecurity it brings, I have the chance to experience the felicitous experience of (my) desire's self-constitution as desiring, which is when desire becomes its own because.

When critical activity and desire become, in rising forth, their own immanent cause there comes to our world an appearance that shows itself as it is. And on this morning I cannot help but think that with such an appearance singularity is born and, moreover, a divine happiness bursts into our world and, for once, heaven is nowhere else than on earth.

Take 8

Passion

There are circumstances in which to be asked 'What can you say?' calls for an opinion to be given. In relation to something preceding the question, you are asked to speak your mind, say what you think, offer a point of view. *What can you say about . . .* You may be bursting with confidence and excitement about what you are going to say. *I've got to tell you this. I don't think anyone has said it before.* Or you may feel hesitant, worried and very unsure. *I really don't know how to say it. I don't know if it is the right thing to say. I might have got hold of the wrong end of the stick.* But then you may feel that you have nothing to say whatsoever. It is unimportant to you. Why bother. *It's got nothing to do with me. Why should I care about what happens to them? They don't belong to what I belong.* Then again someone might say something about something and add: *That is my point of view. You may not like it, but it is my honest opinion.* And with all these instances of speaking has it been taken for granted, by he or she who speaks or listens, that with each utterance, no matter how assured or not, a self has been asserting itself in language? Is this what the question 'What can you say?' is asking me to do? Is it asking me to take it for granted that, in responding to it, a self is asserting itself in language? But this would be to presuppose a

self; and didn't the question come because self-presupposition wobbled?

It cannot be said that the question 'What can you say?' has come to solicit an opinion; for, the question is merely asking *what*. And what this *what* exposes you to is the immeasurability of all that can be said: without being asked in relation to something, some topic or issue, the *what* of 'What can you say?' exposes you to pure potentiality. And for a moment your mouth gawps. *What can you say?* Nevertheless you do start to say. You can *not* not say.

You have been saying, and you continue to do so – you are persevering. And with this perseverance what you have become aware of is not only desire and perseverance going hand in hand but also the *speaking* of speaking. Indeed, in responding to the question 'What can you say?' you have noticed that in speaking, or writing, you slip silently into becoming speaking-being, which refers not to a being speaking (about this or that) but, rather, *being* speaking. Becoming speaking-being you pass into a way of being whose ethos and being is *in* language: you become the pure passion of communication.

Each time I speak, you speak, she speaks, he speaks, they speak, we all pass into speaking-being; our way of being becomes *being* communication. With speaking-being nothing is communicated about this or that; for, we have become that which is nothing other than a passion to communicate. Truth be told, we have become the *passion* of revelation. And being purely this passion, we have become that which has nothing whatsoever hidden behind or below it. We have become that which is utterly as it is.

Becoming speaking-being, nothing is left behind you; there is no reference to a self that stands prior to an act of asserting itself in language. It is not that anything is abolished here, least of all yourself – you are nothing other than yourself, your utmost

self. And you are your utmost self because as speaking-being you appear without latency and become a *being* that doesn't precede or remain below itself. Absolutely absorbed by this non-latency, you are, simply put, nothing other than *exposition*.[1]

Immanent to every utterance made, every concrete specificity of a speaker or writer going about communicating this or that, is speaking-being, but no one hardly notices this. Yet, on this morning, I cannot help but notice that becoming the pure passion of communication you and I have the chance to appear without the burden of latency. But this isn't to say that appearing as such we will know nothing of impotentiality.

Becoming the pure passion of communication you, whomever you are, become a passion to say (communicate), and that you *can* (say, communicate) is your power (*potentia*). However, because you are this passionate being you are also capable of being unable to say – you are capable of impotence. Passion is originally passivity and to be a passionate being is to be capable of being passive with respect to passivity itself, which is to be capable of impotentiality. So, you are a passionate being not because you have a power to overcome and negate impotentiality but rather because you can endure it: your power is that you *can* suffer your own impotentiality, *can* say nothing, *can* be the power to not do, to not be. And what *can* shows us here is an instance where potentiality and impotentiality cannot clearly be distinguished.

Becoming the pure passion of communication you are, first of all, an extreme passivity. There is no other way to put it: you are impotent with respect to your impotence, which means impotentiality comes to impotentiality. So, you *can* not say; yet, with impotence coming to impotence you also can *not* with respect to this *can* not. And what emerges here, as potentiality and impotentiality become indistinguishable, is a capacity to *not* not say.

Perhaps you have wanted to flee. *How can I endure the dark night of impotentiality?* Yet in not fleeing, impotentiality turns back on itself: you are capable of *not* not communicating. You can *not* not say. The words fall from my lips and with them comes no shame or lament:*you* become a golden morning. You are a golden morning and you shine not because you have victoriously battled against the dark night of impotentiality but, rather, because it is inhered and safeguarded within you.

TAKE 9

Love

How can I endure the dark night of impotentiality? Was this the question I was unable to say? Was this the question that I was unable to spit from my mouth? If this were the case, then I would have to say that impotentiality came to impotentiality. Maybe the question wasn't that of how the dark night of impotentiality is to be endured; nevertheless, it was impotentiality that brought forth the question 'What can you say?' Indeed, this question came because impotence – speechlessness – made it such that neither a verbalising self nor the existence of language could be presupposed. And now there is the wonder if the question came so that *you* who respond to it, you who become the pure passion of speaking-being, do not take impotentiality as 'a fault that must always be repressed' but, rather, understand it to be the extreme passivity that is, first and foremost, the passion of communication.[1] And if love is essentially passion, then isn't it love that enables you to suffer this (your) impotentiality?

Nothing in particular

The question 'What can you say' is asking *what* and it is asking *you*. The question does feel personal (soul-searching courses through the body), yet in its asking, you, as an indefinite pronoun, could be anyone. And this makes the question valid for all. It matters that it is you and, equally, it matters not who. You could be whomever. And whomever is what you and I become in becoming speaking-being, and this is because speaking-being, which refers not to a being speaking but *being* speaking, does not speak as a particular. It matters not what person. It matters not who. Anyone, anyone at all, can be whomever, but whomever isn't so easy to classify.

Nowadays it is possible to walk whilst speaking on the phone. Walking past someone who is such a mobile phone speaker, I can hear what they say, but I am not an eavesdropper. I cannot help but hear what they say. *You must be joking! I hadn't realised.* I do not know and can only guess what the content of this conversation is; for, I cannot hear and perhaps don't want to hear what is said by the person to whom this person walking is speaking. And it is because I cannot hear the content of the conversation that I take notice of this particular walking person becoming the whomever of speaking-being. For sure, this walking person

speaks as a particular – *I hadn't realised* – yet, at the same time, they are, as speaking-being, the no-one-in-particular that is whomever.

Speaking-being is irreducible to a particular identity and, what is more, no *communiqué* comes with it. And this is so because speaking-being is nothing other than the pure passion of communication, which as such is devoid of content and the identity of this or that. And in saying this to you, I have slipped silently into speaking-being; indeed, along with the person who is mobile whilst speaking on the phone, I have become no one in particular. I do not know the person speaking on the mobile phone, and they do not know me. Yet what we have in common, as speaking-being, is being *whomever*. We are *both* no one in particular.

To become whomever is to become utterly common; it matters not who. Indeed, in becoming whomever, we come to belong to a community of which it is hard to say exactly what the conditions of belonging are; for, the community of whomever welcomes anyone and no one in particular. I cannot say what the conditions of belonging are, but what I can say, because I cannot say, is that with the community of whomever there is, simply, belonging. With the community of whomever there is a radical generosity towards belonging, and what I can say with respect to this generosity is that the community formed of and by whomever doesn't rest upon presupposition.[1]

The community of whomever is not, by any means, exclusive; it extends a welcome to whomever. Yet taking up a place in the community of whomever, we come to a place that is fundamentally in question. As whomever we come to a place that belongs to no one in particular, which means that we can never, as whomever, call it one's own. And the consequence of this is that the place of whomever is a place where unceasing

substitution takes place: whomever is immediately *in the place of the other*, which is to be in a place of substitution.

In the community of whomever there is no place that does not open onto and cast us into another's place. What transpires here is a space that is hard to represent; however, we who are whomever are at ease in this space, we can move freely within it. And we move so freely because we belong to a community that comes about through the impossibility of exclusion – whomever is immediately and continually in the place of the other.

As whomever we never come to take up a place because there is only a *coming* to a place. Simply put, occupation does not happen. As whomever we experience nothing that is of the nature of a point (we are definitely not a punctual self); on the contrary, in taking up a place that immediately opens onto and casts us into another's place, we become nothing but pure movement, by which I mean movement that is freed from stopping at, arriving at and departing from, a point. In never taking up a place (point), whomever becomes a movement that goes only towards its taking-place.

Hearing these words said I find the word singularity on the tip of my tongue. But should I let this word fall from my mouth? (Is it possible that, with taking-place of whomever, singularity has the chance to appear?)

In the community of whomever there is no place that is not immediately opening onto and casting us into another's place; there is only ever an incessant *coming* to a place. And a place that is always already going towards another place gives rise to a taking-place, a pure movement, that has nothing prior to it or concealed below it. As whomever we are dispossessed of a particular identity yet what comes to us and never stops coming is a taking-place that is freed from the structure of presupposition – the taking-place of whomever is always utterly exposed.

Perhaps I am trying to say too much, perhaps I am say-
ing far too little; nonetheless, what I am hazarding to say is
that the taking-place of whomever is a taking-place that is, in
always being exposed and freed from the structure of presup-
position, self-constituting. And on this morning I am thinking
(and the thought is fragile here) this is precisely constitutive of
singularity.

I have let the word fall from my lips and having done so I
have let the taking-place of whomever and singularity touch and
become interlaced. However, in having let this happen I must
say that the 'self' of the self-constituting that has been said of
whomever (singularity) is not synonymous with an individual
or particular being. Far from it – doesn't the taking-place of
whomever involve a radical displacement of the place of someone
in particular? I would be the first to admit that to speak of self-
constituting is perhaps misleading (the self that transpires here is
so very fragile); nevertheless, what I am entertaining, welcoming
and considering with whomever *and* singularity is a taking-place
that isn't determined by anything other than the taking-place
itself.

On this morning I have found myself drawn to the thought
that to appear, to take-place, without presupposition, residue,
remainder or reserve, is what is constitutive of singularity, and
having let the taking-place of whomever and singularity touch
and become interlaced is to proffer that singularity is in no way
exclusive. I have spoken of a taking-place that isn't determined by
anything other than the taking-place itself; yet, with whomever,
which is always already a community of no one in particular,
this 'self' determination does not settle a boundary that includes
by excluding; for, whomever – *singularity* – is that which comes
about through the impossibility of exclusion. What is more, to
become whomever is to become utterly common; it is to become

no one in particular and anyone at all. And letting the taking-place of whomever and singularity touch and become interlaced is to proffer the thought that the utterly common and singularity are not debarred from participating in each other. Perhaps I am mad to let whomever and singularity touch; but, then, perhaps there is happiness to be had in letting this happen.

With whomever there is no particular type; moreover, there is no representable condition of belonging that would make *whomever* a member of a general type. Let me put it like this: whomever is nothing other than atypicality, which is to say that whomever thwarts the operation of having a type, be it general or particular, bestowed upon it. And now I find myself having to ask if atypicality is another way to say singularity.[2]

The atypical is precisely that which surprises the work of ascertaining a particular type of *this* or a general type of *that*; indeed, it is that which evades being placed as the taking-place of either (a) this or (a) that. And to say that singularity is atypicality would be to affirm that singularity is that which arises *such as it is*.

On this morning I have been trying to find out how I can say singularity and with respect to 'whomever' it has so far been said twice. It has been said as a taking-place that goes only towards itself and which, as such, is a pure exposition in that nothing remains hidden beneath it or anterior to it; and it has also been said as that which is atypical, which as otherwise than untypical means that no type whatsoever can be taken as given, which is to say, presupposed. And what is common to these two sayings of singularity – what is common to whomever – is that presupposition has no place.

Contingency

You must be joking! I hadn't realised. I hear these words spoken by someone who is walking whilst in conversation on the phone, and because the content of this conversation is unknown to me, what is noticed, with these words uttered, is the someone walking slipping silently into speaking-being. The person who is mobile whilst speaking on the phone is most certainly communicating – *I hadn't realised* – yet (and this isn't so easy to say) as speaking-being they make no actual communication. And why no actual communication is made is because speaking-being is nothing other than the pure passion of communication, which is without content and the identity of this or that.

It can be said that the pure passion of communication is to be *in* communication, to be *in* relation, to be talking, speaking, writing. Becoming speaking-being is to have rapport 'in one's power'; it is to become the pure potential to communicate, the sheer possibility of any communication, any relation or predication, whatsoever. And the someone walking whilst speaking on the phone is this pure potentiality at the same time that, with the words spoken by them, a potentiality has resolved itself into an actuality – *I hadn't realised.* With these words spoken, the potential to 'do' communication has become actualised; however, as

the pure passion of communication we are, first of all, rapport in its passivity. And rapport in its passivity is nothing other than rapport suffering its own receptivity, which is when receptivity suffers not something that is impressed or imposed upon it but, rather, only itself. In other words, it is the potential to communicate undergoing and becoming capable of its impotentiality, which again is to propose that all potential to do or be is always also the potential not to do or not to be.[1]

Becoming speaking-being is to exist in the mode of potentiality: you (language) *can* say and, at the same time, you (language) can *not* say. The someone walking whilst speaking on the phone is, as speaking-being, as whomever, both a potential to communicate and a potential not to communicate, but I am not sure they realise this.

The potential *not to* is the dark night of potentiality, yet without it potentiality would have no existence. If potentiality were always only the potential to be, it would only ever be found in the act or actualisation, and if that were the case we would never experience potentiality as such. Only by being also a potential *not to* can potentiality remain irreducible to actuality and have an existence distinguishable from it.[2] For potentiality to not be subsumed by actuality, it matters that it can endure an extreme passivity with which comes the 'abyss of potentiality', which is a darkness like no other.[3] To be able to undergo this passivity is the passion.

As speaking-being we are the passion of communication and this passion is originally passivity, which is why with it no actual communication is made and speaking-being is devoid of content and the identity of this or that. Indeed, the 'communicative emptiness' that comes with the pure passion of communication is nothing other than language in the mode of potentiality and being capable of *not* saying.

On this morning, the question 'What can you say?' hasn't come to solicit an opinion on something; it is simply asking what *can* you say. However, although simply asking, this is where things become complicated: what the question is exposing me to is the innumerable possibilities of what, in our world, can be said. But these possibilities are unfathomable, and they are unfathomable more so because they exist only in the mode of potentiality, which is to say that they are not stored somewhere awaiting utterance and the chance to see the light of day.

Truth be told, I find the existence of potentiality difficult to consider, yet if potentiality is to have an existence and not be overruled by actuality it matters that potentiality is capable of *not being* in actuality. To be capable of not passing into actuality, and thus not being said, is what sustains the potentiality of what can be said. What *can* be said is truly unfathomable because, as potentiality, it descends into an abyss that is simply its own potential not to be said, which is its potential to be said. And if I am to care for potentiality and not banish it from our world, then it would seem to matter that I admit that what *can* be said becomes said with its own potential not to be said.

I cannot deny it, the question 'What can you say?' is, in its mere asking, exposing me to pure potentiality. And for a moment my mouth gapes. *What can I say?* I cannot say. And that I cannot say makes me wonder if the question is coaxing me to dip my pen (or is it my tongue) into the abyss of potentiality and in so doing welcome what actually becomes said as being said by its own potential not to be said. And let me say that if, on this morning, I do welcome the potential *not to* and leave my mouth gaping then I also admit that what does become said on this page is written with a little drop of that darkness that is simply the potential not to be written. And to admit this is to receive the potential *not to* as the very matter from which what actually is said is created.

Yet with this reception there comes a strange experience: it is as if the words that have been said, that *can* be said, have, on this page, written themselves. But, although the experience is strange, there is nothing mysterious about it; for if what can be said is created by the potential-not-to-be-said then what actually is said is said by no one, no thing. Indeed, if what can be said (and forgive me for the mouthful here) becomes said by its own potential-not-to-be-said then who or what can we say has said it. For a felicitous moment, I am not the author or creator of these words – they have written themselves.

It is *you* who responds to the question 'What can you say?' and in responding you are, whomever you are, your potential to say; yet, what you do say – *You must be joking!* – is said with your potential not to. And no matter what opinion, statement or woe is expressed – *I hadn't realised* – you are for a moment contrary to a (presupposed) self asserting itself in language. What you are is a being that hasn't driven potentiality from the world but, rather, welcomed it as your mode of existence.

What does your freedom consist of? That you can say whatever you want whenever you want? That you have the power to do this or that? That you have the power to refuse doing this or that? Isn't your freedom being potentiality? For potentiality to exist and continue it matters that it is not taken over by actuality; it matters that there is a 'to come' that is 'not yet'; and for this to be preserved it matters that potentiality is capable of not being in actuality. Your freedom is that you can be a *passionate being*, which is nothing other than you – and me – being capable of enduring the passivity that is the potential not to.

I am wondering if the question 'What can you say?' is coaxing me to stick my tongue into the abyss of potentiality (so bitter, so sweet) so as to have a taste of the freedom that (possibly) comes in welcoming the potential not to speak, which is the potential

to speak. However, I am also wondering if the question came so as to encourage me not to dwell in the abyss and to turn im-potentiality back upon itself and let something be said or indeed be asked. To whom or what can I appeal to allay the query of my wonder? Does it matter? I don't know. But what I do know is that whatever can both be and not be is what has been named *contingent*.

A contingency is a remarkable occurrence, and it is remark-able because at the very moment that it (whatever) happens it could not have happened. And a contingency is precisely what happens when a potentiality-to-be-said passes into actuality and is, quietly or loudly, said. That potentiality is both a potentiality-to-be-said and a potentiality-not-to-be-said means that what ac-tually is said could equally not have been said.

In responding to the question 'What can you say?' – and being exposed to pure potentiality – everything that you say is the remarkable occurrence of contingency. And on this morning I will go so far as to say that every act of predication, every saying of something, every saying of something about something, is a contingency. Whatever the opinion stated, whatever the certainty extolled, whatever the anxiety tremblingly expressed, whatever the misery moaned, it could have not been said. And that it could have not been said means that in speaking (or writing) there is, with language, something experimental going on. Indeed, what does become said, as a remarkable occurrence, is for me, at least on this morning, an *experimentum linguae*.[4]

Potentiality opens the possibility of not letting something be said, yet it also opens the possibility of letting something be said, and when the potential *not to be* turns back upon itself there comes an act that does indeed let something be (said). And potentiality turns back upon itself when, in suffering the passivity of which it is capable, it comes to a point where it submits to itself – it

can *not* not be (said). Let it be said! To be sure, what is said is a contingency – it could have not been said – yet it is a remarkable occurrence because that it has happened means that saying *yes* to letting it happen has indeed happened. So be it. It need not be so, but it is thus. And what this *thus* affirms is simply that it is *accordingly*, which is to say, in the manner as it is.[5] And this 'as it is' is precisely what makes the contingent occurrence so remarkable.

Having dipped my tongue into the abyss I find that, in hearing these words said, singularity is again on the tip of my tongue. And again I ask: should I let it fall? Indeed, should I let this word *be* where a contingent occurrence makes the remarkable (that is to say, singular) occurrence of that which need not be but is *thus* and not otherwise and, accordingly, as it is.[6] Let it be. And letting it be said, this word singularity will be, as with everything else said on this morning, a contingency (it could have not happened) and an *experimentum linguae* (let it happen).

Take 12

Shimmering

On this morning that will last god knows how long, my thinking has received the potential *not to*, which is perhaps 'that which cannot be thought and yet must be thought.'[1] Indeed, my thinking has admitted an extreme passivity and powerlessness that is personal and yet, at the same time, impersonal. The potential not to say, do, be or think is the passion of potentiality, but what matters is how this passion, this passivity that is perhaps the 'nonthought within thought', is thought.[2] I am most certainly feeling an imperative (it *must* be thought), but will thinking that which cannot be thought (the potential not to think) be my darkest hour?

How am I to think of passive potentiality, which is nothing other than potentiality being capable of not passing into actuality? Was this the question that, on this morning, I was unable to spit from my mouth and which rendered me speechless, powerless? Indeed, was this the question that, unuttered, brought forth the asking of 'What can you say?' and to which, momentarily, I could not (preferred not?) to respond? I still cannot say, but I can say that in those early morning hours, those minutes so long and formidably measureless, I was demolished. I was blank. I could not say 'I'. Was that my darkest hour? Or is that hour

yet to come as I meet the imperative to respond to the question of how passive potentiality is to be thought in relation to actuality?

Am I to think of passive potentiality as an actuality that is merely deprived of itself? Indeed, am I to think of passive potentiality as the proper existence of something – its actuality – undergoing its privation? However, if passive potentiality, which is the potential not to pass into actuality, is thought of as an actuality that is merely deprived of being in the present, then, time and time again, actuality – what is present – gains primacy over potentiality. *Are we too accustomed to think in terms of the present?*[3]

I freely admit that I find passive potentiality hard to think. And why I find it particularly difficult is because my thinking has the habit of thinking the power-not-to-pass-into-actuality as a withdrawal of a power-to-be-present-in-actuality. A bad habit, perhaps. However, if I am to meet the imperative that beckons me then, surely, I must do more than think of passive potentiality as simply the absence of a presence. I must do more than cry out in anguish: *Why have you forsaken me?*

How am I to think, in relation to actuality, passive potentiality; indeed, how am I to think pure potentiality? As for this question announced on this morning I make an appeal: let me be with you for just one more hour. (And the question does stay like a dog beside me. Or, is it me that has become the dog, faithful to end?)

— How am I to think pure potentiality?

The word 'pure' falls from my lips. Let it fall. Let it be. But what do I mean by this little word, this adjective that lies faithfully next to potentiality? What I mean is potentiality in its

fullness. Yet with this fullness what I see immediately is an empty totality with which, at first, I can only see as black.

And then I find myself saying that black is the colour of the passion of potentiality, the colour of that which is capable of not passing into actuality and which (possibly) sustains the unfathomable life (can I say this word?) of potentiality. The passion is black and black because with pure potentiality there opens up that which is entirely empty. However, this empty totality is potentiality in its fullness; it is the blank wax tablet on which all texts, beautiful or damaging, true or false or meaningless, remain unwritten. And the blank is *blanc*. It is white, the sum of all colours. Yes, 'the totality of all colours composes white'. The blank: 'all the possible is there, implicated; all the possible is here, virtual.'[4]

On this morning, this morning where I am trying to find out what I can say, I'll say that pure potentiality is non-exclusively both black and white: it goes in both directions at once and, with this movement making a sparkling alternation, produces a shimmering zone of determination between the blackness and the whiteness but which never ever makes grey.

I'll say that pure potentiality is both black and white, but I'll not say that it is a black and white situation; for, with it, everything is in question, including the word 'everything'.

Everything that is said in response to the question 'What can you say?' is accompanied by an empty totality shimmering beside it; moreover, such an empty totality can also be found shimmering beside the no-one-in-particular that defines whomever.

Let me say more.

You are asked 'What can you say?' However, the question hasn't come to solicit an opinion because it is not asked in relation to something (some topic, issue or concern) that precedes it. The question merely asks *What?* And with any response given,

no matter how brazen or brash, is that the uttered becomes, in the act of its utterance, exposed to the blank tablet upon which all texts, beautiful or otherwise, remain unwritten. And that this exposure happens means that whatever is ventured to be said is a contingent occurrence, which is remarkable (singular) in that it need not have happened but has happened and is thus. What is said is thus and not otherwise, yet it could have been that which never was said. Indeed, the contingent is an occurrence of a power to be, but this occurrence doesn't exclude the possibility of that other power, which is the power not to be.

Contingent names that which can both be and not be, which means that whatever is said in response to the question of what you can say goes at once in two directions. It goes towards actuality and, at the same, towards pure potentiality; indeed, it 'shuttles in both directions along a line of sparkling alternation'.[5] Whatever is actually said, albeit thus and not otherwise, incessantly goes towards and remains in contact with the (empty) totality of possible utterances. As that which never was said, these possibilities know nothing of actualisation, which is why the totality is totally empty; yet, through sparkling alternation, this empty totality, which is potentiality in its fullness (and, who knows, perhaps the 'nonthought' within thought), remains shimmering beside everything that is said in response to the question 'What can you say?'

Whatever materialises on this page remains exposed to the totality of possible utterances that potentially could have appeared but which have not appeared and accordingly continue as the passive potentiality – the power not to be – that sustains the unfathomable life of pure potentiality.

You who are addressed by the question 'What can you say?' are an indefinite pronoun and although it matters that it is *you*,

you could be anyone. You could be whomever. And let's say that you are happy to become an example of whomever.

You are happy to be an example of whomever, but you are not the only possible example; as with any example, no one example can claim to be the only possible one and this is even more so in the case of whomever. Any example of whomever can be at any time substituted for another example of whomever and what results from this is that any one example refers to and stands for all those other examples; yet, because this one example can be replaced by any one of those possible examples of whomever, it is also included among them.

Anyone who enters the community of whomever, which offers a welcome to everyone and no one in particular, can assume the place of an example of whomever, and this place incessantly goes towards all those other possible examples that can equally take up this place and be substituted for any one example. In short, the place – and life – of an example of whomever is that of perpetually opening onto a space of substitution. Which is to say, the place is fundamentally in question.

You are here as an example of whomever, yet being here you are also elsewhere: your life is unfolding in a space that is adjacent to you. In this life that is unfolding beside you, you are incessantly going towards and bordering upon a space of substitution that is nothing other than the totality of possible examples of whomever; but it has to be said that this space – this totality – is empty and empty because it is never occupied. In a space of substitution a place is never taken up.

You who are living the life of an example of whomever have shimmering beside you, around you, a space that is tremulous as a result of its vicarious nature. This space, this empty totality of possible and substitutable examples of whomever, offers no

place (to defend or relinquish), yet you who are an example of whomever are perfectly at ease in this space: it belongs to no one and you can move freely within it.[6] And who knows, perhaps tomorrow I will say that this space, empty of any particular place, is a radically public space.

Story

To say that with pure potentiality everything is in question (including the word 'everything') suggests that the passing from potentiality to actuality is a response to a question: *What can you do, be, or, indeed, say?* Now, you may wonder if this is actually the case, but for a moment let this not be a worry and consider only that this question is addressing passive potentiality, which is the potential *not to* pass into actuality. Yet making this consideration I would have to say that the *you* that the question is addressing is in no way a subject; for, with the potential *not to* it cannot be said that a subject is there. With passive potentiality there is no subject, although the language that discourses here will happily and readily produce one for it. How hard it is for me to speak of passive potentiality without this becoming the subject that is, in a sentence, presupposed to be some substratum, something or someone.[1] However, for the moment I shall not let this be a worry.

So, let us consider that passive potentiality is asked, 'What can you do, be or say?' But immediately there is the question: by whom? 'Who are you who asks . . . who are you to ask the question?' However, if passive potentiality were to be given a voice and become a character, which would be in effect to

anthropomorphise it, it would be stupid of it to ask this question. And it would be stupid because in so asking it would install the authority of a commanding imperative: 'Answer the question!' And accordingly, any response given would be caused by and subservient to the presence of another. So upon being asked 'What can you do, be or say?' passive potentiality does nothing, says nothing. It stays silent and endures its passivity. Yet in that silence there begins the making of a response. And because there has been no asking of who it is that asks, the response that is made by passive potentiality is not caused by nor answerable to another. The response that is made is nothing other than an invention. And in the event of such a response there comes the transmutation of powerlessness into power.[2]

In the time that passive potentiality stayed silent and endured its passivity it did not say 'I refuse to speak'. It did not utter 'No, I will not answer!' But what it did do in the silence of not a word spoken nor a deed done was to save the life (so empty, so full) of pure potentiality. It did not save what *is*. On the contrary, it saved that which *was not*, and it saved it for the benefit of a time to come.

How strange it sounds to hear of 'that which was not'. Perhaps it sounds strange because with these words uttered what is heard, at least by my ears, is language straining. Hearing 'that which was not' I can feel language exerting its utmost in an attempt to say what seems impossible to say. With 'that which was not' being uttered what all too quickly happens is that the word *was*, although soon followed by *not*, makes me believe that there was something that never became present. Believing this, however, is tragic. What is more, with 'that which was not' being uttered a temporal articulation becomes made and, again all too quickly, the potentiality that accompanies these words is consigned to the past and taken to be no longer. But let's be sure: what never

happened is not in the past. It was not (done or said) but it *is* not *was*. The potentiality *is*. And this is precisely what was – is – saved. The potentiality of that which never happened remains, which means it remains for the benefit of – *let's hope* – a time to come or, in other words, for the benefit of change.

Take 14

Experience

In that moment when you were asked what can you say and your mouth hung open such that all manner of small winged creatures had the opportunity to fly in and out, you could have, in feeling the imperative character of the question and perhaps in sheer desperation, spoken of your life and experiences. Maybe you would have spoken of that time when, as a child, you were run over. A sports car it was, travelling fast through a village that rarely saw cars but frequently had children tearing across its single, straight, road. Perhaps it would have been that first time in hospital when tonsils had been taken out and jelly was going down in lumps as tears were battled against as parents were departing and leaving you there for yet another night. Or maybe you would have plucked up the courage to speak of that person who betrayed a friendship and did underhand deeds. Maybe you would have even spoken their name.

With lived experience falling from your tongue perhaps you were thinking that – surely – this was the one thing you could speak of in response to the question of what can you say. Yet, with the words spoken, would there have come the supposition that lived experience, happy or sad, is antecedent to and distinguishable from the words that bring it to life?

But you are considering, at least on this morning, that 'life is what is made in speech and what remains indistinguishable from it'.[1]

Hearing these words that do not fear life dwelling in speech, you cannot deny that what is lived – your life – is not immune from fable. (Hasn't fable, *fabula*, got something to do with speech?) Indeed, with life being made in speech and remaining indistinguishable from it, you cannot deny that you could construct your lived experiences on the basis of a fabulous invention. And then speaking of your life and experiences perhaps you would speak of those terrible times when you were subjected to a war that had insidiously incited an insurrection that had caused cherished ones to be profoundly silenced and took from them the life that breathes in the word. Maybe you would not speak of this life that had had its heart ripped out but, rather, gather words to have word, world and life remaining tight together. And maybe you would do this so as to say that the words that speak of your life and experiences do not minister to the biographical paradigm that in modern times bends ears and sells books. Was not biography, autobiography, formed by a catastrophic separation that tore life from its ties to speech and made it become so-called real life?

Biography would have us believe that lived experience is antecedent to the words that speak it and bring it to life; however, this can only be believed because a laceration between life and speech has resulted in life departing from speech.[2] The real life that biography is in the service of has had the life that breathes in the word sucked from it. Biography: it is nothing living.[3] So-called real life does not truly live; it can only require that it is said to live. Departing from speech, life does not live in speech; on the contrary, it becomes a fact that speech is required to report. *She lived in the poor part of town.*

For some, biography accepts, wittingly or not, a division that, in the end, leaves life isolated. Is this you? Is this you who upon being asked 'What can you say?' could have responded by speaking of that car accident, that betrayal, that insurrection? Is this you who could have said such things but only because you are one who cannot accept the end of the interlacement of life and speech?[4] But then, being such an unaccepting one perhaps you would have simply said, 'I speak'.

What is revealed in the simple assertion 'I speak'? For sure, what is revealed (but nothing is hidden here) is an assertion that coincides exactly with itself. It is simply true that I am speaking when I say that I am speaking. However, in saying 'I speak' things may not be that simple.[5] With 'I speak' being said no discourse commences; there is only a naked articulation. And what appears with articulation is an absolute opening through which language can (potentially) spread forth.[6] A discoursing subject does not speak, but what does speak is an 'I' that does not take itself to be prior to language. Indeed, here we do not hear a self speaking of a lived experience that is antecedent to language; for, the matter about which I speak, that I speak, does not pre-exist its utterance, that is to say, language. What does speak is an 'I' that does not presuppose itself. Indeed, what does speak is an 'I' that shows each and every 'I' (*I* was run over by a car) that *I am never anywhere but in saying I.*[7] And saying these words 'I' has access to itself: in not presupposing itself something of 'I' doesn't remain below, hidden and separated from itself.

TAKE 15

Matter

On this morning I could have responded to the question 'What can you say?' by immediately speaking of my life. Although these words speak of something that could have happened but which didn't happen they nonetheless make me immediately want to ask: What is this life that the pronoun 'my' here possesses?

I'll not beat about the bush: there is no life that can be separated from forms of life that come to appear. There is no life that exists prior to and remains behind or beneath all the forms that can and do appear, which is to say life has no proper identity. This life of mine, which at times I cherish and at other times find all too much for me, is not in possession of a proper identity; for, the matter of life is always possibilities of life, and this means that, in actuality, each and every form retains the character of a possibility – it has happened but it need not have happened. In life (and death) I become a particular person of whom it can be said has such and such qualities. *She was loquacious. No, no, she was taciturn. She moved like a centipede, lots of little steps moving fast. No, no, she was like a wasp.* However, before I am that person I am no more than and no less than a possibility. Better still: a potential possibility.

That there is nothing of life that can be separated from life and said to be *it* from which our forms derive means that, as possibilities, we are, life *is*, nothing other than improper. 'Life . . . is, in truth, improper.'[1]

Life is life only in so far as, in taking-place, life goes towards all of its 'improper' possibilities. Which is to say, the matter of life isn't to be found below the form but, rather, only ever beside it.

Taking-place as a possibility of life, my life is improper. Perhaps our original sin is that we humans take such impropriety as something to be ashamed of and so search, sadly, for a proper identity. But if we happily give up this search we will find that as 'improper' possibilities we are not already enacted. Would that be good for you?

Closeness

The words have fallen from a million mouths and have been written endless times; nevertheless, I simply have to say: *I love you*. Perhaps, however, the declaration of love would be better said as this: *I am unable to be unable to love you*. And why these words would be better is because the love that is expressed by them has wrapped up within them something of the inability that is the pure potentiality, let's say *passion*, of love.

I love you, but will this love expire if the potentiality of love disappears in the act of loving? The question leads me to say that love requires a potentiality that is irreducible to every definite act of love, which necessitates that in actuality there remains passive potentiality. True love requires true potentiality, which is when the text remains unwritten on the blank tablet and love is unable. *I am unable to love you*. However, saying this is not the same as saying that I do not love you, and nor is it a matter of circumstance: *I would love you if I could but I love another and it is with this other that my fidelity lays*.

It can be said that, at heart, potentiality is the passion to not be; yet it can also be said that there truly is potentiality when the potential *not to* passes fully into actuality. And I'll say that this passing happens when, in undergoing itself, passive potentiality

submits to itself, folds back upon itself and is unable to be unable. And when passive potentiality is unable to be unable, which truly is love's passionate being, it is fully expressed and passes fully into actuality.

I am unable to be unable to love you. With this expression there is a folding back that effects an unfolding, which as such is, definitely, the appearance of love. But of this appearance I must ask: Is it dressed in red, is it sovereign?[1] Or, does it bear the lightning of possible storms?[2] On this morning, I'll say yes to the latter. And saying yes to it means that I must say more, must find out more, must explicate.

I am unable to be unable to love you. With these words filling the air, a cry of expression can be heard. But even though an 'I' is spoken, the cry does not belong to the interiority of the person who utters the present instance of the discourse containing 'I'. On the contrary, the cry is an expression of pure potentiality, which is the potential *not to* pass into actuality.

The word expression has appeared, and I welcome it. And, moreover, I welcome spending time with the expression of potentiality that I am hearing in the words *I am unable to be unable to love you*; for, what is beckoning me is the idea that expression and potentiality go together: expression is emergence and as such is simply, but never simply, the potential for what may become.

Expression is emergence; it is unfolding itself. As emergence, expression is always *for* something to come; and with this as its ethos (a way of being that is always *for* potentiality) expression itself unceasingly seeks furtherance, that is to say, a (re)potentialisation for further expression. Being unfolding itself, expression is continually emerging into things and words and thought; their emergence in the world is the very emergence of the world. Indeed, the result of expression's unfolding is definite and determinate objects, subjects, bodies, minds and

institutions. Which is to say, expression is ontogenetic, a force of existence.

For expression, the emergence of actual things, be they words, thoughts or things that fall off the table, is a necessity. This is expression's explication and without it, expression would not be expressed. I'll put it like this: the expressed – the emergence of the world – has no existence outside of its expressions, which are myriad. And let's make no mistake about this: what moves here is a concept of expression that is freed from any reference to transcendence.[3]

What does it mean to say this? On this morning I'll say that it means that the taking-place of expression, of emergence and unfolding, is not made answerable to nor dependent upon something that remains beyond it, behind it, and which could be called 'emanative or exemplary cause'.[4] It means: expression is an emergence with which there is no remainder.

The unfolding of expression (potentiality) evolves a definite emergence – that face over here, that kiss there – yet this ex-plication also evolves, *involves*, expression as that which is *for* the still yet to come. With the emergence of definite things, so necessary for expression, potentiality has passed into actuality, which is when passive potentiality is unable to be unable and folds back upon itself; yet, expression is always a two-way thing: it is unceasingly both unfolding and enfolding.[5]

The unfolding of expression (potentiality) is the emergence of definite being yet potentiality (expression) is not exhausted or annulled in this act. Far from it. The unfolding is equally an enfolding, which is to say that every definite act of love has wrapped within it a charge of potentiality: *I am unable to be unable to love you.*

For expression to unfold itself it is necessary that it becomes incarnate in a body, in the widest sense of the term. And it is

necessary twofold. It is necessary so as to be expressed and also so as to move on, to go beyond. With expression becoming expressed in that face over there or that kiss here there is unfolding; yet, at the same time, there is enfolded, there and here, the potentiality for new emergences, which maybe unnameable as either face or kiss. Through explication, expression and potentiality pass fully into actuality, and with this coming to pass expression and potentiality have become enfolded for further self-redefinition. That there is the emergence of an actual world and all those definite occasions (of love, minds, bodies, subjects and objects) means that potentiality – the power-not-to-pass-into-actuality – remains *in* and not transcendent of the world.

For expression, the emergence of actual things and words and thought is necessary, and this is when the deed is done; but, there is no subject beneath or beyond whose deed it would be. There is expressive agency, but there is no substantive here. The lightning strikes and there never was a subject there before its befalling.[6] And when the lightning strikes and expression is expressed there is a pure appearance of love. The appearance has nothing whatsoever hidden behind or below it, yet immanent to it, enveloped within it, is that which is *too much to be born*.[7]

On this morning where I am saying to you that I am *unable* to be unable to love you, I find myself saying that expression has two aspects: expression is always both a power to be and a power to not be, and what is more, it is continually unfolding and enfolding both these powers, both these potentialities. There is the actualisation of potentiality in definite forms of expression (the potential to be) and then enfolded within these forms is that potentiality (the potential to not be) that is too much to be born but which, in resisting the present and not passing into actuality, is the potential for what may become.

78

For its existence, in the realm of expression, the power to be does not treat the power to not be as its presupposition. The power to not be does not remain beneath and behind every emergence of the power to be; on the contrary, it is the lightning of possible storms that is enfolded within it. This in-dwelling potentiality is an inside that is deeper than any interior and, at the same time, an outside more distant than any exterior. Or to put this another way, it is the outside that is something more distant than any external world but also something 'closer than any inner world'.[8]

(As the potential for what is still to come, expression is unceasingly moving to go beyond, and with this potentiality enfolded in that which emerges in the world there also emerges a transcendence that is not transcendent to and separate from the world but, rather, immanent to every expressive body and existence that is an unfolding of the world. And that is a closeness I welcome.)

The lightning of possible storms is the potential for love to come – or, better still, the potential for what love might become. Why should these words be better? I'll say they are better because an idea of love is not placed before, as first and foremost, the possibility of realisation. To speak of 'love's possibility' is to allow, unwittingly or not, potentiality to be related, if not subordinated, to a preformed idea (subject or element) from which love (or whatever) is taken to emerge by simple realisation. With the idea already in place, and not taking-place, possibility becomes merely the idea of something that has existence withdrawn from it. (And something in these words echoes that habit of thinking potentiality as the proper existence of something – its actuality – undergoing its privation.) However, the lightning of possible storms stops there being an idea (of love or life) that has already been formed and taken place before the flash.

Endeavour

And still there is uncertainty as to the question that you were unable to throw from your mouth and which brought forth the asking of what you can say. For sure, you have ventured to say the question. *How can I speak without presupposition? How am I to say singularity? How are we to think the groundlessness of the linguistic without negativity? How am I to live a happy life? How can I endure the dark night of impotentiality?* However, after at least sixteen attempts of finding out what you can say, you still cannot say — uncertainty remains as to what the question is.[1] Maybe this is the question: *Why should anyone care if actuality gains primacy over potentiality?*

Personal

Who thinks I am blabbering away? If it is you then I would have to tell you about the silences that have fallen hard as language has become flummoxed and known not what to say next. On these occasions, language has been so strained that if it were to speak it would say 'I'm reaching my breaking point', but let there be no doubt about it, language doesn't make a sound, neither a squeak nor a murmur: it is suffering a pressure that has delivered it to silence.[1] And believe you me, such silence has been hard because, on this morning, words are all that I have.

Language has more than once suffered silence, yet of this sufferance and silence it can say nothing. And it can say nothing for there is a lack of way for language to utter the silence without filling it. Is this 'lack of way' akin to the difficulty met when there appeared to be no way for the communicability of language to say itself in that which it grants?

On this morning, a communicative emptiness had confronted me, and I could say nothing. Indeed, an aporia had halted me in my tracks: How can language's passion to communicate, signify, express or reveal, say itself?[2] But now, in trying to find out why I should care to think of the existence of potentiality and, moreover, care that potentiality or possibility is not taken as the

proper existence of something – its actuality – undergoing its privation, I can say that the communicative emptiness is language in the mode of passive potentiality.

What has been called communicability, and which can be also called 'expressibility', is language existing as an ability, a *passion*, to communicate or express, yet this ability, this passion, doesn't in itself communicate or express anything; for, as it now can be said, it is nothing other than language as an original passivity or, in other words, the potential not to be said, which is the potential to be said.[3] Only because language can say or express nothing (the potential not to be said) is it possible for language to not exhaust the potentiality for expression.

If the potentiality for expression – of 'being said' – were to have disappeared in the actual expression then the world would always already have been said, and the world would silently weep because, for it, there would be no further expression, no expression yet to come. Perhaps I am blabbering away in response to the question 'What can you say?' But what I cannot help but say is that language desires to be, and perseveres in being, the potentiality for expression – this potentiality is not only the furtherance of itself (and the voice it gives to the personal – *I'm reaching my breaking point!*) but also the prevention of the world withering and dying from having no more expression.[4]

Existing as the potentiality for expression language says nothing, and this nothing is precisely that which is too much to be born; it is the passive potentiality that is capable of not passing into the actual present but which remaining immanent to every actual expression – *You look beautiful today* – pulls language into direct contact with its own futurity. This pulling can make what is actually being said twist and yelp – *me here, me, who can tell you all this, could have and don't and didn't tell you* – yet in this event an emergence glints as innovation turns.[5] And no matter how slight

or timid this emergence may be, it is remarkable in that, with it, there is innovation precisely because the emergence is that which hasn't already been spoken for; indeed, it is not an idea that, having had existence withdrawn from it, is now making its realisation, and nor is it an actuality that having undergone the privation of its proper existence is now dressed in red and finally appearing. And why I would personally hold out for passive potentiality not being subordinated to actuality is because this *passionate* potentiality is what offers resistance to the present and provides the chance for innovation in any situation, albeit fragile, robust or profound. To not be indifferent to actuality gaining primacy over potentiality is to hold dear to myself that there are possibilities other than what we are told is possible.[6]

Beside, and paraphrasing

I hear of a conundrum that concerns the position of the means through which things, be they hard or soft, of human relations or not, become known to us. What I hear is that 'if the form *(species)* or image by which a thing is seen and known were other than the thing itself, we would never be able to know the thing either through it or in it. But if the form or image were completely indistinct from the thing, it would be useless for knowledge . . . If the form that is in the soul had the nature of the object, then we would not know through it the thing of which it is the form, because if it itself were an object it would lead us to the knowledge of itself and it would divert us from the knowledge of the thing.'[1] Paraphrasing, it could be put like this: *if the word through which a thing is expressed were either something other than the thing itself or identical to it, then it would not be able to express the thing.*[2]

What is of concern, and the source of the trouble, is the position of that by which something becomes known to us; and let's make no mistake about it, there is here no dream that things are immediately knowable. If that by which something becomes known existed in a position either different from it or exactly the same as it, then it would cease to be that which makes a thing seen

or knowable. If it were in front, it would conceal the thing, and if it were elsewhere, over there, it would be another thing. But what if it had a paraexistence? The Greek word *paradeigma* says it well: *what shows itself beside*. And that is exactly the position where we will find the example. Paradigm simply means example – that which is placed next to something.

What in our world cannot become an example? I cannot answer this without giving you an example. To make use of an example is a common thing that we human animals do. We use examples to explain things, to show things and make them knowable and, perhaps, other things beside. Imagine someone who has no knowledge of a tree. *What is a tree like?* You wonder what they must have endured not to know this; nonetheless, you find an example and show it. *This is what a tree can be.* You are both standing next to a particular tree, a big handsome tree, yet this tree is also standing as an example of a tree.

Every example stands as a real particular case – a kiss has to be given in order to give an example of it – but it also has to hold for all cases of the same type, which means it cannot serve in its particularity. No one possible example can claim to be the only possible example; yet, although one among others, the example has to stand for each and all. The example must serve for all others of the same type, but it also has to be included among these. And what can be said here is that the example stretches the distinction between the universal and the particular, the general and the individual; it is, characteristically, neither one nor the other. And what is also characteristic of the example is that it exhibit that of which it is exemplary. The example makes an exposition.

The example shows itself as belonging to a class or set of which 'kiss' or 'tree' are common to it. The example endeavours to show its belonging and make the set intelligible, yet in so

doing a strange movement occurs – the example steps outside and becomes excluded from the very thing that it is showing it belongs. The moment an example of a kiss *shows* that it belongs to the very thing of a kiss (and here I am not talking about a mere peck on the cheek) it steps outside the 'normal' (I use the word cautiously) case of a kiss.[3] To serve as an example the kiss must be treated as a proper kiss, otherwise it would not be showing what a kiss can be. However, as an example the kiss cannot be given and received as a real kiss; for, the very thing of a kiss only applies to a real, proper, kiss and not an example of it. And this is why the example is found in that paradigmatic position; that is to say, the position that *shows itself beside*. Given as an example, a kiss is not a kiss but still is a kiss; it is the very thing of a kiss, as it were, beside itself.

An example shows itself beside that which it both defines – this is a kiss – and makes knowable; and I remember well one wet summer's afternoon when such showing went on. There we were, three girls and one boy, spending an afternoon giving each other examples of a kiss. We were showing each other what a kiss could be like, but the kisses given and received were not private and personal kisses; on the contrary, they were public exhibitions. Indeed, what took place between boy and girl, between girl and girl – it really didn't matter – were expositions of a kiss, which as such hid nothing.

On that wet summer's afternoon, a kiss, a proper grown-up kiss, was being shown to be knowable to four eleven-year-olds, and they all knew that the kisses given and received were both the very thing and not the thing. And the same can be said of those two others who stood next to an example of a tree. For them both, the tree seen was not the tree itself but, rather, the tree shown beside itself. *It was as if the form, the knowability, the features of the entity, were detached from it, not as another thing, but*

as an . . . angel, an image . . . it was a paraexistence that dwelt beside
the thing, so close that it almost merged with it. It was not the identity
of the thing and yet it was nothing other than the thing.[4]

The example does have a paraexistence yet with it there is no
conundrum as to the position of that by which something becomes
known to us. The example is neither completely indistinct from
the thing nor another thing; it is the thing – the tree, the kiss –
in the 'very medium of its knowability'.[5]

If a word is able to express the thing this is because it becomes, in
the spirit of an example, that which is neither something other than the
thing nor identical to it. Let's be clear, with the example it is not
the phenomenon that is being seen but rather the phenomenon
being seen by the means of that which shows, and exposes, its
knowability and which can be called its *eidos*, its face. Using other
words, we may call it 'image' or, indeed, 'idea'.

An example sets out to 'make knowable' yet it doesn't take
as given that which it seeks to make knowable, which is what
often happens with the case of a hypothesis, which in Greek
means 'presupposition'. An hypothesis has an idea that is thought
suitable to explain something, but what so often happens is that
the idea presupposes the 'something' that it would explain. The
idea makes an hypothesis out of it and then endeavours to show
that it has the 'know-how' to explain it. But here the idea chases
after its own tail; for, that which it takes as given in reality – the
something – is only a presupposition of the hypothesis that would
explain it. And while the idea chases after its own presupposition,
what there is to be explained and made knowable, which we can
say is unpresupposed, remains hidden. The example, however,
has an idea that is different from this.

In its movement of stepping outside, the example endeavours
to make an exposition of the thing it dwells beside. The example
makes an exposition and what comes of this is that the example of

a tree shows an exposed being or, better still, a being-exposed –
the example makes an exhibition and shows you the thing 'being-
such'. You can indeed say that this gives you an idea (or image),
but let's not forget that this idea is an exposition. The idea doesn't
take the thing as given; rather, the idea shows you what it can
be. Indeed, with the idea that the example gives we do not find
the thing presupposed; on the contrary, we find it exposed and
opening to its knowability.[6] Which is to say, we find it *only* in
its coming-into-being-known, and this is to find it as what it can
be. With the example, the thing can appear as this, but as this
example is not the only possible one, it need not appear as it does
appear as such here – I can give you an example of what a kiss
can be, but there are other possible examples.

The idea that an example gives is the thing beside itself ex-
posed in its own coming-into-being-known; and shown as what
it *can* be, it is the thing exposed to its possibilities. Or better still:
shown as what it can be, the thing or phenomenon is found not
established once and for all but, rather, amid its potentialities. In
a word, the example is a *potentia*.

Unfixed

Everything you say in response to the question 'What can you say?' is an example of what can – what *could* – be said. However, the utterances can be said to be examples, but that of which they are examples I could not draw a picture; yet I can say that each and every example is a *potentia*. For sure, a potentiality has been actualised by the tree that is being shown as an example of what a tree can be, but it need not have been so. Which is to say, an example is contingent and necessarily so; for, no one example can claim to be the only possible example – that of which the example is exemplary need not appear as it appears with this possible example.

What I would say is fundamental to the life of an example – no one example can puff itself up and proudly proclaim that it is the example above all others. Let us say you are a tree. You are a tree 'in person', yet as an example you have entered a community where there is no place that is not vicarious. To live the life of an example means that at any time another could be substituted for you and you are yourself a substitute for another.

As an example you are standing for all 'cases of the same type' and because you can be replaced by any of these other possible examples you are also included among them. Which is to say, and

to reiterate, that your place is going towards and opening into all those other possible examples, each of which knows no place of its own and is immediately cast into another's. Your place, as an example, is hardly a place at all, but it is always already common . . . *each being occupies a particular place where each being is always already substituted for another being who is in an always other place.*[1]

The example doesn't show the phenomenon of which it is an example established once and for all; rather, it shows it in its coming-into-being-known. The example shows the phenomenon being-such; it shows us the phenomenon as what it *can* be. And what this *can* does is to expose the phenomenon to its possibilities – this example is one of its possibilities. But there is more. Through its life of substitution, this possible example is opening into all those other possible examples for which, at any time, it can be replaced, which means that the phenomenon is being exposed to *all* its possibilities. And it must be said that with all these possibilities there is no one that is definitive. Indeed, no one example of what a tree can be is definitive of the identity of a tree.

I can say that, even if it is of something audible like birdsong, an example gives an image. I could equally say that an example gives a view or an idea. However, none of these images, views or ideas are bound by an ideal or a fixed and proper identity. An example both exhibits and defines the thing of which it is an example, but what transpires in this act is that the example also unravels it of identity; for, with the example and its life of substitution the thing is going towards all those other possible examples; indeed, it is 'beside itself' touching all its possibilities, no one of which is fixed and final and exhaustive of it. As an example, you define and constitute that of which you are an example yet, at the same time, you also unfix it, deconstitute it, undetermine it and shatter the 'pretence of absoluteness'.[2]

An example of a butterfly is shown to me, but nothing absolutely definitive is happening here: what is being shown – butterfly – is coming only amongst its modal variations. And this is precisely what I was shown when, in a box of childhood things, I discovered an incomplete set of small cards showing, in landscape format, all sorts of butterflies. Each illustration, each card, gave an example, and laying out all the cards with their edges touching, I saw an exposition that explained to me that the butterfly is made up solely of versions. With six cards across and eight down, a rectangle was formed, but the rectangle was incomplete as there were only forty-seven cards – in the bottom right-hand corner there was an empty space. This space did not speak to me of something missing; on the contrary, it exposed and made intelligible a space of substitution.

Any one example is immediately opening onto, at least, forty-seven other possible examples, and this is showing me that the butterfly is, itself, made up solely of versions: each of these versions is an example of what a butterfly can be; each is a *potentia*. And this explains the fact of the butterfly's existence as possibility or potentiality. Indeed, what the example is showing me is *passionate being*.

As an example, the butterfly is beside itself in an adjacent space, yet this adjacent space is not another space that lies beyond; on the contrary, it is the passage, the medium, through which the thing of a butterfly has access to itself.[3] With the thing of a butterfly shown in the medium of its knowability – that is to say, shown as what it can be – we find the thing (of a butterfly) transcending towards itself; for, in the paradigmatic place of the example, the thing is only found *coming* amongst its modal variations and, thus, going towards its possibilities, which are, as it were, itself. But there is no transcendence here. Far from it, the thing is remaining in itself as it incessantly comes to itself.

The butterfly is 'flowing out' in the medium of its knowability and is, at the same time, coming to itself. And here the butterfly is not a being that remains below itself. On the contrary, the butterfly is living a life of immanence.[4]

The example endeavours to show you what a butterfly can be like and, in so doing, a movement occurs in which it steps outside to show you what is innermost to the taking-place of the butterfly. This is the exposition that the example makes, and what occurs with this exposition is that the example forms a passage through which the butterfly comes to its taking-place, ex-presses itself and has a face. And with this expression, the butterfly enjoys an appearance that is its innermost exteriority – and that is a face and a taking-place behind or below which nothing is hidden. With such an appearance the butterfly is found only in the midst of 'being-such', and fluttering here the butterfly is free of presupposition, including self-presupposition.

Lesson

On this morning a vision had beckoned me to see it. And I looked, and I could not look away. And not looking away what I saw was the appearance of appearing itself. What I saw was perhaps too much to see – my eyes were red. But I was not weeping, and nor was the appearance dressed in red. For sure, there was a show but there was no pomp – and, call me naive, neither did I see secrets here. A lack of secrets – is this not what you find with the example?

That which *shows itself beside* – the example – makes an exposition and shows that of which it is an example in its knowability. With this exposition the example is showing *potentia*: it – whatever – can appear such as this; or, better still, it can appear being *as* such. Indeed, the example shows you that of which it is an example not established once and for all, not presupposed, but, rather, in the midst of its *as*. And there, in the midst, we find *as* shimmering in a sheer appearance, and with such an appearance there comes appearing itself, which is when appearing appears with nothing whatsoever hidden behind, below or beyond it. On this morning, I cannot look away. And not looking away, let me ask if this *as* will be permitted with the case of the child who has

been sent outside the classroom and made to become an example of bad behaviour.

She had just perfected the art of flicking small balls of rolled up paper. His ear, the target. Success. Another ear, another success. But then the restlessness of members of her class draws the teacher's attention to her activity. She is to go outside of the classroom and stand there as an example of bad behaviour. And there she is standing, but standing there a paradoxical existence and movement has begun.

In making bad behaviour knowable, the example is showing that her behaviour in the classroom belongs to a class, or set, that consists of cases of bad behaviour; however, in so doing, the example has stepped outside and become excluded from the very class of behaviour of which she is a member and example. Has the child been made to stand outside the classroom in order to show this aspect of the example; indeed, are those pupils in the classroom seeing that, with the example standing outside the classroom, bad behaviour is manifesting beside itself?

Considered as an example, the child's bad behaviour is not the thing, yet it is not another thing: it is the thing shown beside itself exposed in its knowability. And here it has to be said (again) that we do not find the thing presupposed; for, as exposed, it is shown only in its coming-into-being-known. That is to say, it is shown as what it can be. And with this exposition, the thing (bad behaviour) is exposed to its possibilities; however, this exposure also unravels it of a definitive identity. As an example, the child is defining bad behaviour yet, at the same time, she is also *undefining* it. Bad behaviour is not being shown established once and for all; rather, it is being shown in the midst of the *as* of *being as it can be*. Indeed, outside the classroom, the example is standing there as an *as* that is shimmering in its appearance. And this *as* brings no presupposition: it is not referring back to something preceding it

and which, as already there, can be taken as given. But would the teacher, in teaching the lesson, prefer that this *as* presupposed and referred back to something preceding it? I cannot say, but what I can say is that referring back and presupposing are what pronouns, like *this*, have been understood to do.

What can I say? What I can say is that with the demonstrative pronoun *this* we find language making only a denotation and asserting nothing, which is precisely what happens when language announces a name.[1] In itself, *this* is an empty sign. However, *this* doesn't simply refer to an unnamed object; for, what is characteristic of the pronoun is that it indicates an instance of discourse.[2] It is through this indication that *this* comes to refer back to a preceding term and make the empty sign full by indicating that *this* means *as that*.[3] With *this* meaning *as that*, *this* receives a proper referent and meaningful discourse happens. However, for *this* to be *as that* presupposes that language has already shown you something — *as that* is *as this*. With the pronoun *this* we have this *as that* yet with *as that* language has shown you *as this* — *that is as this and this is as that*. And what occurs here is the double movement of a 'reciprocal implication', and with this double movement there opens up a delicate interval in which we are in the midst of *as*.[4] For a moment we can see *as* not presupposing and referring back but exposed: we can see the sheer appearance of *as*. No strings are attached, and it is for me, at least on this morning, glorious to see.[5]

TAKE 22

An example

A vision

As soon as I point to a tree as an example *this* particular tree becomes a so-called tree. And the same goes for the child who is sent outside the classroom and made an example: as soon as the threshold is crossed, the child stands as so-called bad behaviour.

What is characteristic of the example is that it suspends its immediate factual reference.[1] With this suspension, the so-called tree doesn't indicate the existence of *this* tree; it doesn't show that this particular existence *is*. A tree belongs to the genus 'tree' and, moreover, belongs to it as an example of it, which is to say that any tree whatsoever can be an example. Any particular tree can stand as an example, but because it has to stand in the place of whatever is called 'tree' it cannot serve in its particularity, which is precisely why immediate factual reference has to be suspended. And what comes of this suspension is that, in appearing as an example, any particular tree appears *without being confined to the actual particularities of its appearance*.[2] And it would be the same case if the example were to be a so-called human being.

Disassociated from any sense of cynicism, the so-called is strictly the commonly called; it is the most common tree (or human being). To be sure, the so-called tree shows you what is meant by such a thing as a tree, yet being shown the most common

you are shown is a non-particular tree – any-tree-whatsoever. And you look, and in looking you see that with an any-tree-whatsoever the definitive tree, the tree of all trees, is engulfed. Seeing an any-tree-whatsoever commonality is repeatedly approached, and this certainly involves *any* tree in a belonging; yet, with the definitive being engulfed, what you cannot pin down is the *what* that would define and give meaning to the conditions of belonging.

With the so-called tree you are not shown the immediate being-there of this (particular) tree. Which is to say, with the words 'so-called' there isn't a whispered *this* that is denoting and giving immediate factual reference. With the so-called tree, which is any-tree-whatsoever, you are not shown *this* and, what is more, you are not shown *that*, which is to say what stands as defined and defining of identity and meaning. But what the example does show you is whatever *is called* tree. And what holds you, with this exposition, is the pure being-called that is occurring – the phenomenon is *being-called* (tree). Certainly, you are not seeing the thing; yet you are seeing that which is nothing other than the thing and not another thing. And seeing this you are astonished, and that you are astonished leaves you speechless. What can you say?

The phenomenon is being-called and what astonishes you is that in this event you cannot completely distinguish the phenomenon (tree) from its being-called 'tree' (. . . it is not the thing, yet it is nothing other than the thing). Which is to say, you are definitely not hearing language exercising a power of naming that is exerting an authority over some non-linguistic thing.

There are no other words for it: you are seeing the thing in the midst of *as* being-called. *As* is not referring back to and presupposing some (prelinguistic) thing, but it is shimmering; for, what you are seeing is a double movement, and it is taking

place between the name 'tree' insofar *as* it is naming the tree and the tree insofar *as* it is named by the name 'tree'. This is the exposition that is being made to you, and with it you are seeing a delicate interval in which arises a pure appearance – a pure being-in-language. And it has to be stressed that this appearance is neither the thing as denoted by *this* nor the thing as meant by *that*; it is neither the non-linguistic thing that the name only announces and of which says nothing, nor is it the thing's being in language as that which is said of it in a predicative assertion. It is not the non-linguistic 'morning' that has to be presupposed in order to say 'brings daylight'. Which is to say, it is neither the subject presupposed by discourse nor what is said in discourse of it.[3] For you, it is the moment when you see what is named by the name appearing in language in the form of not its presupposition but, rather, its exposure. Although nothing whatsoever is hidden here, this is not the thing appearing, but it is not another thing; it is nothing other than the thing: it is the thing's sayability – expressibility – in language.[4]

And you will say, for one more time, that this sayability in no way concerns a real determination of matters in speech. And you will follow this by saying that, although it is easily missed, sayability exists in everything that, in a given situation, can be said.[5] And shortly after this, and without fear of repetition, you will say that, *as* being-called, the thing that appears in language that is neither the denoted thing nor the meant thing, that is not the thing and yet nothing other than the thing, is the phenomenon beside itself, going towards itself, touching itself, in the medium of, the *pure passion* of, its sayability.[6]

You cannot deny that seeing the pure being-in-language that is sayability, expressibility, is a delicate matter, yet on this morning you have seen it as nothing short of a vision. And you will add that this vision is equally and inseparably a vision of language

itself – the pure passion (*potentia passiva*) that is both preserved (the lightning of possible storms) and actualised (unfolded) in everything that is said, no matter how banal or almighty. Indeed, what you are apprehending, thanks to the example, is language announcing its passion.[7] Simply put, you are seeing language *in* love.

A question in the making

On this morning a vision of language has kept coming to you and insisting that it be seen. You have not had the ability to look away – you have been powerless not to see. And you have found the vision beautiful to see, not only because it has given itself to be seen but also because it has shown you, and kept on showing you, the expressible (the sayable), which is, for the taking-place of things in the world, a pure relationship with, a pure exposure to, the taking-place of language itself.

The rain is falling fast. What is first and foremost announced with these words is being-manifest-in-language. The manifestation, however, pertains to neither the non-linguistic rain as denoted and presupposed by the name 'rain' nor the rain's being in language as that which is said of it, *is falling fast*, in the predicative assertion. What the manifestation pertains to is an expressible dimension within language. To be sure, this dimension – the expressible – isn't so easy to grasp, yet for you, on this morning, it has been *suddenly brought to birth in the soul, as light that is kindled by a leaping spark.*[1] Perhaps apprehending the expressible is always of the order of a vision.

With the expressible there is no substantive to be apprehended or grasped. Indeed, the expressible is not a substance; it

is not a being that has something of itself remaining below itself, which is precisely what happens when presupposition happens. Call it insubstantial. Call it incorporeal. Call it event.[2] Call it what you will, but the expressible is not, by any means, a thing. But it does provide the means by which there is, in the world, being-in-language.

Being-in-language is not another thing towards which the thing (the rain falling fast) tends, but neither is it simply the same thing. You will say that the expressible is the thing – *whatever* – transcending towards itself taking-place in language. And again you will say that it is a pure relationship with language and nothing other than exposure. And what this exposure shows you is 'opening to knowability', which demonstrates that, with language, there is an openness to and an immanent relationship with a world, which is beautiful to see. And you are powerless not to say that this exposure *as* exposure is absolutely *thus*. As such, it is a taking-place that, on this morning, you have persevered in calling singularity.

For the taking-place of things in the world, the expressible is pure exposure to the taking-place of language, and with this exposure there comes an absolute *thus*, a *thus* that is not referring back to any referent or meaning, not presupposing anything.[3] The thing is transcending towards itself taking-place in language; it is simply thus. The thing is simply thus and so too is language; for, what is also happening with this pure exposure, this *thus* that is not presupposing, is that the taking-place of language is equally exposed. And you smile as the taking-place of language does not slide into either an antecedent position or a sup-position.

The *thus* that is the word for the expressible is barely a linguistic term (little of language is actually happening here), but it is shimmering with potentiality. And you will say that what makes *thus*, the expressible, passionate being is that in its

midst (it is nothing other than midst) we are at the threshold of im-potentiality being unable not to love.

A vision of language has been insistent that it be apprehended. For sure, your eyes are red, but the insistence has made it possible for you to finally say the question that stuck in your throat and rendered you speechless (what can you say?), that made you taste impotentiality (so bitter, so sweet), that has remained an obscurity yet persevered in asking you (*you* whom it matters not who but equally matters that it is you) that it be uttered and, accordingly, for you to feel your belonging to a community that, in being extremely generous in welcoming no one in particular (whomever), is free from presupposition and enjoys singularity.

— How do you regard language?

Dividing the division

The nocturnal have gone to their nests and the animals that have them are flexing their vocal cords as they say in so many different ways – *Good Morning*. As the world's cacophony makes itself heard, which it is prone to do as night becomes morning, what I am holding dear is what happens when a pure *as* arises and no clear distinction can be drawn between the taking-place of a phenomenon in the world and its being-called, which is when the taking-place of a thing in the world is found *thus* in language and the taking-place of language is also found *thus*. And what happens is that presupposition does not happen and a non-division takes place.

With the pure *as* and *thus* that arises with the expressible, which is a delicate matter, little of the linguistic is actually happening, yet its insistence to be seen has made it possible for me to apprehend a non-division. In the midst of *as* and *thus* no presupposition takes place, and without presupposition taking-place what freely takes place is a non-division between 'the linguistic' and the 'non-linguistic'.[1] This non-division does not take away the 'non' of the 'non-linguistic' (it does not reduce all to the linguistic); to the contrary, with the passion of being *unable* not to love (passionate being) turning in its midst, the 'non' of the

non-division is raised to a second power and, accordingly, acts to divide the division that produces it. The division is divided and with this there comes the non-non-linguistic.[2] But this is not the end of the story.

With the division between the linguistic and the non-linguistic being divided what becomes irrelevant is the fact of there being in the world 'being(s) with the word' and 'being(s) without the word'. And the irrelevance is so precisely because with the division being divided 'being without the word' (call it Nature if you will) becomes 'being not without the word', which is not the same as 'being with the word'. I'll admit, this isn't so easy to think, yet if I stick with the divided division what shows itself to be 'empty' is the caesura between *humanitas* and *animalitas* that is based upon having/not having the word.[3] And what I glimpse with this emptiness is the community of no one in particular extending its welcome to not only *whomever* but also *whatever*.

Citation and Annotation

Opening

1.1

For an exposition of the problem of 'Voice' see Giorgio Agamben, *Language and Death: The Place of Negativity*, trans. Karen E. Pinkus with Michael Hardt, Theory and History of Literature Series, Vol. 78 (Minneapolis: University of Minnesota Press, 1991).

1.2

To reveal revelation itself is to reveal the '*passion* of revelation': this is an application of an expression from Giorgio Agamben, *Means without End: Notes on Politics*, trans. Vinncenzo Binetti and Cesare Casarino, Theory out of Bounds Series, Vol. 20 (Minneapolis: University of Minnesota Press, 1991) p. 92.

1.3

'The face's revelation is revelation of language itself. Such revelation, therefore, does not tell the truth about this or that state of being, about this or that aspect of human beings and of the world: it is *only* opening, *only* communicability.' Ibid.

Obliteration

2.1

Three lectures, under the title of 'The Nature of Language', were intended by Martin Heidegger to bring us face to face with the possibility of undergoing an experience with language. To 'undergo an experience with language' means that something befalls us, which is to say that the experience is not of our own making. To undergo an experience with language is to submit to language, and if it is true that we humans find our 'proper abode' in language, then submitting to it we will touch the 'innermost nexus of our existence'. See Martin Heidegger, *On the Way to Language*, trans. Peter D. Hertz (San Francisco: HarperSanFrancisco, 1982) p. 57.

2.2

'In experiences which we undergo *with* language, language itself brings itself to language. One would think that this happens anyway, any time anyone speaks. Yet at whatever time and in whatever way we speak a language, language itself never has the floor'. Ibid., p. 59.

Division

3.1

'Destiny is concerned only with the language that, faced with the infancy of the world, vows to be able to encounter it, to have forever, beyond the name, something to say of it.

'This vain promise of a meaning in language is its destiny, which is to say, its grammar and its tradition. The poet is the infant [Latin: *infans* – unspeaking] who piously receives this promise

and who, through avowing its emptiness, decides for truth, and decides to remember that emptiness and fill it. But at that point, language stands before him, so alone, so abandoned to itself . . . ' Giorgio Agamben, *Idea of Prose*, trans. Michael Sullivan and Sam Whitsitt, Sunny Series (Albany: State University of New York Press) p. 49.

3.2

Agamben goes as far to say that 'because the event of language always already transcends what is said in this event, can something like a transcendence in the ontological sense be demonstrated'. Agamben, *Language and Death*, p. 86.

3.3

'The scission of language into two irreducible planes permeates all of Western thought, from the Aristotelian opposition between the first *ousia* and the other categories . . . up to the duality between *Sage* [saying] and *Sprache* [speech] in Heidegger or between *showing* and *telling* in Wittgenstein'. Agamben, *Language and Death*, p. 85.

Agamben goes on to say that the very structure of transcendence – 'which constitutes the decisive character of philosophical reflection on being' – is grounded in this scission. Ibid., pp. 85–6.

Heidegger wants us to undergo an experience with language (2.2), and this experience is that of language saying. This saying (*Sage*) remains unsaid and unsayable in human speech, yet for Heidegger it can be experienced in human speech; however, this unsayable aspect of language reproduces, at least for Agamben, the division of language into the two distinct planes of 'the very taking place of language' and 'meaningful discourse', which

corresponds to what is said within the taking place of language. See ibid., p. 85.

3·4

Modern linguistics makes a distinction between *parole* and *langue* and for Giorgio Agamben this distinction expresses the scission of language into irreducible planes. On the one hand, discoursing speech (utterance or message) and, on the other, the event of language (or code). See ibid., p. 86.

3·5

That an event is not a something, that it is incorporeal, is explored in my *Sounding the Event: Escapades in dialogue and matters of art, nature and time* (London and New York: I.B. Tauris, 2005).

See for example: 'Events may be understood as changes, but the structure – logic – of the subject–predicate distinction would have us believe that with the change there is some substance, some SOMETHING, that is changing. (The apple, in the bowl on the kitchen table, is rotting). Events may be understood as changes, but the category of a distinguishable SOMETHING so dominates that when it is an issue of the location of an event, the event in question is located by locating the SOMETHING that is, supposedly, undergoing the change . . . (Locate the apple and then you will locate the event of rotting.) However, Alfred North Whitehead's event . . . is asking us to think *event* otherwise than this and make the subject–predicate distinction quiver.' Ibid., pp. 96–7.

And: 'With every event there is the time of its actualisation or embodiment in a state of affairs . . . The moment of actualization pertains, temporally, to the present, but this is not so with the event that is the [incorporeal] *effect* of intermingling bodies. With this event nothing in the present happens, although it is the living

historical present of mixed bodies that brings it about'. Ibid., p. 147.

Appearance

4.1

'Evil . . . is the reduction of the taking-place of things to a fact like others . . . With respect to these things, however, the good is not somewhere else; it is simply the point at which they grasp the taking-place proper to them, at which they touch their own non-transcendent matter.

'In this sense – and only in this sense – the good must be defined as the self-grasping of evil, and salvation as the coming of the place to itself'. Giorgio Agamben, *The Coming Community*, trans. Michael Hardt, Theory out of Bounds Series, Vol. 1 (Minneapolis: University of Minnesota Press, 1993) p. 15.

4.2

'"It appears" – how strange the grammar of this verb! On the one hand, it means *videtur*: "it seems, it appears to me as a likeness or semblance, which can therefore be deceptive", on the other, *lucet*: "it shines, it stands out in its evidence"; here, a latency that remains hidden in its very yielding of itself to sight; there, a pure, absolute visibility, without shadow'. Agamben, *Idea of Prose*, p. 125.

Movement

5.1

In making reference to the 'Yes I can' said by the poet Anna Akhmatova, in the 1930s, in response to a woman who month on month joined queues of women outside the prison of Leningrad

and had asked 'Can you speak of this?', Giorgio Agamben says that Akhmatova's answer was not born from her knowing how to handle language with respect to atrocious things of which it is difficult to write. On the contrary, it was Akhmatova's moment to utter *I can*: 'For everyone a moment comes in which she or he must utter this "I can", which does not refer to any certainty or specific capacity but is, nevertheless, absolutely demanding. Beyond all faculties, this "I can" does not mean anything – yet it marks what is, for each of us, perhaps the hardest and bitterest experience possible: the experience of potentiality'. See Giorgio Agamben, 'On Potentiality', *Potentialities: Collected Essays in Philosophy*, trans. Daniel Heller-Roazen (Stanford, CA: Stanford University Press, 1999) pp. 177–8.

5.2

Aristotle, 'Book Theta', *Metaphysics*, 1050b 10; translation from Daniel Heller-Roazen, 'Editor's Introduction', *Potentialities*.

5.3

'The word must communicate *something* (other than itself). In that fact lies the true Fall of the spirit of language'. Walter Benjamin, 'On Language as Such', *Walter Benjamin: Selected Writings, Volume 1, 1913–1926*, eds. Marcus Bullock and Michael W. Jennings (Cambridge, MA, and London: The Belknap Press of Harvard University Press, 2004) p. 71.

Names

6.1

Agamben takes care to say that a *manner of rising forth* is not a being that is *in* this or that mode but rather a being that is *its*

mode of being. For Agamben, the idea of this 'modality of rising forth' allows us to find a common passage between ontology and ethics. 'The being that does not remain below itself, that does not *presuppose* itself as a hidden essence that chance or destiny would then condemn to the torment of qualification, but rather *exposes* itself in its qualifications, *is* its *thus* without remainder – such a being is neither accidental nor necessary, but is, so to speak, *continually engendering itself from its own manner*'. Agamben, *The Coming Community*, p. 28.

The being that continually engenders itself from its own manner of rising forth does not treat existence as a property but rather as a *habitus*, an *ethos*. 'Being engendered from one's manner of being is, in effect, the very definition of habit (this is why the Greeks spoke of a second nature): *That manner is ethical that does not befall us and does not found us but engenders us*. And this being engendered from one's manner is the only happiness really possible for humans'. Ibid., p. 29.

6.2

'Love is never directed toward this or that property of the loved one (being blond, being small, being tender, being lame), but neither does it neglect the properties in favour of an insipid generality (universal love): The lover wants the loved one *with all of its predicates*, its being such as it is'. Ibid., p. 2.

6.3

'Let us try to imagine an infant [*unspeaking*] . . . completely abandoned to its own state in infancy . . . he would be ecstatically overwhelmed, cast out of himself, not like other living beings into a specific adventure or environment, but for the first time

into a *world*. He would be truly listening to being. His voice still free from any genetic prescription, and having absolutely nothing to say or express, sole animal of his kind, he could, like Adam, *name* things in his language. In naming man is tied to infancy, he is for ever linked to an openness that transcends every specific destiny and every genetic calling . . . Genuine spirituality and culture do not forget this original, infantile vocation of human language . . . ' Agamben, *Idea of Prose*, p. 96–7.

6.4

'The word must communicate *something* (other than itself) . . . in reality there exists a fundamental identity between the word that, after the promise of the snake, knows good and evil, and the externally communicating word'. Benjamin, 'On Language as Such', p. 71.

6.5

' . . . the fracture between name (*onoma*) and defining discourse (*logos*) . . . traverses all of language . . . The plane of discourse is always already anticipated by the hermeneutics of Being implicit in names, for which language cannot give reasons (*logon didonai*) in propositions. According to this conception, what is unsayable is not what language does not at all bear witness to but, rather, what language can only name. *Discourse cannot say what is named by the name.* What is named by the name is transmitted and abandoned in discourse, as untransmittable and unsayable. The name is thus the linguistic cipher of presupposition, of what discourse cannot *say* but can only *presuppose* in signification. Names certainly enter into propositions, but what is said in propositions can be said only

thanks to the presupposition of names'. Agamben, 'Tradition of the Immemorial', *Potentialities*, pp. 107–8.

6.6

'Hegel was the first to truly understand the presuppositional structure thanks to which language is at once outside and inside itself and the immediate (the nonlinguistic) reveals itself to be nothing but a presupposition of language . . . the nonlinguistic is only ever to be found in language itself'. Giorgio Agamben, *Homo Sacer: Sovereign Power and Bare Life*, trans. Daniel Heller-Roazen, Meridian: Crossing Aesthetics (Stanford, CA: Stanford University Press, 1998) pp. 21 and 50.

Happiness

7.1

'Each thing, as far as it can by its own power, strives to persevere in its being . . . by the word *desire* I understand any of man's strivings . . . ' Spinoza, *Ethics*, *A Spinoza Reader: The Ethics and Other Works*, trans. Edwin Curley (Princeton: Princeton University Press, 1994) III P6, p. 159 and III Def.Aff. 1, p. 188.

7.2

'A cause is immanent . . . when its effect is "immanate" in the cause, rather than emanating from it. What defines an immanent cause is that its effect is in it – in it, of course, as in something else, but still being and remaining in it. The effect remains in its cause no less that the cause remains in itself. From this viewpoint the distinction of essence between cause and effect can in no way

be understood as a degradation'. Gilles Deleuze, *Expressionism in Philosophy: Spinoza*, trans. Martin Joughin (New York: Zone Books, 1990) p. 172.

'Immanent causality involves no eminence, involves, that is, no positing of any principle beyond the forms that are themselves in effect . . . With immanent causality causes remain implicated and involved in their effects – an enfolding. However, effects are also the explication, the expression of causes – an unfolding . . . To explicate is to evolve, to involve is to implicate yet, so I hear, the two terms are not opposites. They simply mark two aspects of expression. "Expression in general involves and implicates what it expresses, while also explicating and evolving it." Expression. Here I discover that Spinoza folds a conception of expression into immanent causality. Nothing is hidden; there is neither reserve nor excess. Spinoza's concept of expression: – "What is expressed has no existence outside of its expressions; each expression is, as it were, the existence of what is expressed"'. See Yve Lomax, 'Serious Words', *Writing the Image: An Adventure with Art and Theory* (London and New York: I.B. Tauris, 2000) pp. 173–4; see also Deleuze, *Expressionism in Philosophy*, pp. 16 and 42.

7.3

Desire rejoices in itself because: 'He who imagines that what he loves is destroyed will be saddened; but he who imagines it to be preserved, will rejoice'. Spinoza, *A Spinoza Reader: Ethics*, IIIP19, p. 165.

7.4

This would be to experience *beatitude*; '. . . desire's self-constitution as desiring, is immediately blessed . . . In Spinoza,

the idea of beatitude coincides with the experience of the self as an immanent cause . . . ' Agamben, 'Absolute Immanence', *Potentialities,* p. 237.

'We will say of pure immanence that it is A LIFE, and nothing else. It is not immanence to a life, but the immanent that is in nothing itself a life. A life is the immanence of immanence, absolute immanence: it is complete power, complete bliss [beatitude]'. Gilles Deleuze, 'Immanence: A Life', *Pure Immanence: Essays on A Life,* trans. Anne Boyman (New York: Zone Books, 2001) p. 27.

' . . . 1. We begin with inadequate ideas which come to us, and passive affections which flow from them, some increasing our power of action, others diminishing it; 2. We then form common notions as a result of an effort of selection among these passive affections themselves; active joys of the second kind follow from common notions, and an active love follows from the idea of God as it relates to common notions; 3. We then form adequate ideas of the third kind, and the active joys and active love that follow from these ideas (beatitude)'. Deleuze, *Expressionism in Philosophy,* p. 310.

7.5

A question found in Nietzsche's *The Gay Science* has here been slightly altered. See Nietzsche, 'The Greatest Weight', *The Gay Science,* trans. Walter Kaufmann (New York: Vintage Books, 1974) pp. 273–4.

7.6

' . . . happiness does not lack anything, but is self-sufficient'. Aristotle, *The Nichomachean Ethics,* 1176b 5, trans. W. D. Ross,

in *The Basic Works of Aristotle* (New York: The Modern Library, 2001) p. 1102.

7.7

'One of the principal elements of an idea of critique, from the very beginning, is that it does not rest content with *opinionated arguments about the given* . . . The task . . . is to ensure that the given is never surreptitiously reintroduced into the gestures of critique. This is a more demanding task than the post-Kantian purveyors of critique usually assume'. Iain Mackenzie, *The Idea of Pure Critique* (London and New York: Continuum, 2004) p. xvii.

The importance of Kant is in his survey of the terrain of critique. Kant brought to light what critical activity must overcome, namely indifference. 'Kant . . . correctly identifies "indifference" as the first moment in the development of an idea of critique that decisively shifts "critical philosophy" from the terrain of opinions about the given. Critique, with Kant, becomes critique of criticism'. Ibid., p. xxv.

7.8

'Kant is the first philosopher who understood critique as having to be total and positive *as* critique. Total because "nothing must escape it"; positive, affirmative, because it can not restrict the power of knowing without releasing other previously neglected powers'. Gilles Deleuze, 'Critique', *Nietzsche and Philosophy*, trans. Hugh Tomlinson (London and New York: Continuum, 2005) p. 89.

However, for Deleuze, Kant's critique is exhausted by compromise: 'Kant merely pushed a very old conception of critique to the limit, a conception which saw critique as a force which

should be brought to bear on all claims to knowledge and truth, but not on knowledge and truth themselves; a force which should be brought to bear on all claims to morality, but not on morality itself'. Ibid.

In other words, the criticised has questions asked of it but in itself remains unquestioned.

7.9

'We are not going to think unless as we are forced to go where the forces which give food for thought are . . . It is up to us to go to extreme places . . . ' Ibid., p. 110.

Passion

8.1

'Exposition, precisely, is not a "being" that one can "sup-pose" (like a substance) . . . ' Jean-Luc Nancy, *The Inoperative Community*, trans. Peter Connor, Lisa Garbus, Michael Holland and Simona Sawhney, Theory and History of Literature Series, Vol. 76 (London and Minneapolis: University of Minnesota Press, 1991) p. xxxix.

Love

9.1

'. . . the only ethical experience (which, as such, cannot be a task or a subjective decision) is the experience of being (one's own) potentiality, of being (one's own) possibility – exposing, that is, in every form one's own amorphousness and in every act one's own inactuality.

'The only evil consists instead in the decision to remain in a deficit of existence, to appropriate the power to not-be as a substance and a foundation beyond existence; or rather (and this is the destiny of morality) to regard potentiality itself, which is the most proper mode of human existence, as a fault that must always be repressed'. Agamben, *The Coming Community*, p. 44.

Nothing in particular

10.1

'There can be no true human community on the basis of presupposition – be it a nation, a language . . . A true community can only be a community that is not presupposed'. Agamben, 'The Idea of Language', *Potentialities*, p. 47.

'Community is presuppositionless: this is why it is haunted by such ambiguous ideas as foundation and sovereignty, which are at once ideas of what would be completely suppositionless and ideas of what would always be presupposed. But community cannot be presupposed. It is only exposed. This is undoubtedly not easy to think'. Jean-Luc Nancy, *The Inoperative Community*, p. xxxix.

I do not doubt that thinking such 'presuppositionless' is not easy, but it is important that we think this without lament nor introduce groundlessness and the absence of foundation as 'the empty form of presuppostion beyond all foundations'. Agamben, 'Tradition of the Immemorial', *Potentialities*, p. 113.

10.2

With respect to Gilles Deleuze's concept of singularity, Brian Massumi proffers: 'An approximation of the concept of the singular can be arrived at simply by considering a state of things

not as a member of a class, or a particular instance of an existing type but . . . as an occurrence. An occurrence always presents chance-inflected variations, "accidents" not exhibited by other occurrences with which a propositional system might be tempted to group it according to its order of resemblances. Confronted with these ungroupable aspects, the system can only apprehend them negatively, as anomalies. As anomalies, they can be systematically brushed aside as insignificant. The atypicalities slip out of signification's sleeves.' Brian Massumi, 'Introduction: Like a thought', *A Shock to Thought: Expression after Deleuze and Guattari*, ed. Brian Massumi (London and New York: Routledge, 2002) p. xxvii.

Contingency

11.1

This is again to reference Aristotle's concept of potentiality (5.2).

11.2

For Giorgio Agamben, this is the 'cardinal secret' of the Aristotelian doctrine of potentiality'. Agamben, 'Bartleby, or On Contingency', *Potentialities*, p. 245.

11.3

Melville's Bartleby, the scrivener who *prefers not to*, dwells 'obstinately in the abyss of potentiality and does not seem to have the slightest intention of leaving it'. Ibid., p. 254.

In his writing on the Aristotelian doctrine of potentiality, Agamben says that darkness is 'in someway the colour of potentiality'. Ibid., p. 180.

Darkness (the potential not to) is not cast as other than light; for darkness is the potential for light in as much as light is the potential for darkness.

11.4

You will find the term *experimentum linguae* appearing in Giorgio Agamben's writings on language. In *Infancy and History*, Agamben will speak of an experience that is undergone only within language, 'an *experimentum linguae* in the true meaning of the words, in which what is experienced is language itself'. A little later he will say that every thinker 'has probably had to undertake this experience at least once; it is even possible that what we call thought is purely and simply this *experimentum*'. See Giorgio Agamben, *Infancy and History: The Destruction of Experience*, trans. Liz Heron (London and New York: Verso, 1993) pp. 5 and 6.

11.5

The contingent is being-thus. Giorgio Agamben asks us to conceive of this 'thus' as no longer referring back to a preceding term (anaphora) but, rather, as an 'absolute *thus* that does not presuppose anything, that is completely exposed'. Agamben, *The Coming Community*, p. 94.

11.6

Commenting upon Gilles Deleuze's reading of the being that arises from Spinoza's *causa sui*, Micheal Hardt says that this being is, for Deleuze, *remarkable*. The being that is *cause of itself, in itself and through itself* constitutes the Spinozian principle of the singularity of being, and this being is remarkable for it beholds us to

see the difference of singular being without it having dependence upon or reference to any other thing. The singularity of being is not 'distinct from' nor 'different from' anything outside itself, and it is remarkable (singular) because its difference is in itself. See Micheal Hardt, *Gilles Deleuze: An Apprenticeship in Philosophy* (London: UCL Press, 1993) pp. 62–3.

Shimmering

12.1

Maurice Blanchot speaks of the 'Outside' and under the subtitle 'The passion of the outside' says: 'So we shall be tempted to say provisionally: impossibility is relation with the Outside; and since this relation without relation is the passion that does not allow itself to be mastered through patience, impossibility is the passion of the Outside itself'. Maurice Blanchot, *The Infinite Conversation*, trans. Susan Hanson, Theory and History of Literature Series, Vol. 82, (Minneapolis and London: University of Minnesota Press, 1993) p. 46.

For Deleuze and Guattari, the Outside is the most intimate within thought; it is that which must be thought and that which cannot be thought. And when I hear them say that it is, 'an outside more distant that any external world because it is an inside deeper than any internal world' I cannot help but think that the Outside is the potential not to think. See Gilles Deleuze and Félix Guattari, *What is Philosophy?*, trans. Graham Burchell and Hugh Tomlinson (London and New York: Verso, 1994) p. 59.

12.2

Thinking of the 'nonthought' within thought as the potential not to think enables me to understand why it is the outside of thought

and yet the inside of thought, which is to say: that which sustains the potentiality to think. And why the passion of the potential not to think (the Outside) is impossibility is because it is 'that which cannot be thought and yet must be thought, which was thought once, as Christ was incarnated once, in order to show, that one time, the possibility of the impossible'. Ibid., p. 60.

12.3

'We are too accustomed to thinking in terms of the "present".' Gilles Deleuze, *Bergsonism*, trans. Hugh Tomlinson and Barbara Habberjam (New York: Zone Books, 1991) p. 58.

Deleuze and Guattari cry out: 'We do not lack communication. On the contrary, we have too much of it. We lack creation. *We lack resistance to the present.*' Deleuze and Guattari, *What is Philosophy*, p. 108.

If I were to consider passive potentiality as an 'empty' or 'dead' time in which nothing of the present happens, which is for Deleuze and Guattari the temporality – the meanwhile – that pertains to the Event, then it is possible that the potential *not to* is what can offer resistance to the present. See ibid., p. 158; see also Lomax, *Sounding the Event*, pp. 135–61.

12.4

As Michel Serres reminds us, white is the sum of all colours. Michel Serres, *Rome: The Book of Foundation*, trans. Felicia Mc-Carren (Stanford, CA: Stanford University Press, 1991) p. 36.

I am suggesting that the black is empty and the white full, but this can be reversed: the black is full and the white empty. Taking Livy's history of Rome as his starting point, Michel Serres says: 'The book of foundation is first of all ichnographic. It is written

in black and white. Everything is written on the page of legend, and nothing is written on the page of Alba. *All the possible is there, implicated; all the possible is here, virtual.* There is the full well, and here is the virgin blank. Livy, at the origin, describes the simplest operators – a full, sealed black jar and an open, empty white one' [my emphasis]. Ibid., p. 55.

12.5

'The passage from potentiality to act . . . comes about every time as a shuttling in both directions along a line of sparkling alternation . . . ' Agamben, *The Coming Community*, p. 20.

12.6

As Giorgio Agamben reminds us, the space of 'ease' designates, according to its etymology, the space adjacent. See ibid., p. 25.

Story

13.1

' . . . the popular mind separates lightning from its flash and takes the latter for an action, for the operation of a subject called lightning . . . as if there is a neutral substratum behind . . . But there is no such substratum; there is no 'being' behind doing, effecting, becoming the deed is everything'. Frederick Nietzsche, *On the Genealogy of Morals*, trans. Walter Kaufmann and R. J. Hollingdale (New York: Vintage, 1967) p. 45.

13.2

'Imperatives in the form of questions . . . signify our greatest powerlessness, but also that point of which Maurice Blanchot

speaks endlessly: that blind, acephalic, aphasic, and aleatory original point . . . at which "powerlessness" is transmuted into power . . . ' Gilles Deleuze, *Difference and Repetition*, trans. Paul Patton (London: The Athlone Press, 1994) p. 199.

Experience

14.1

These words are Giorgio Agamben paraphrasing. See Giorgio Agamben, 'The Dictation of Poetry', *The End of the Poem: Studies in Poetics*, trans. Daniel Heller-Roazen, Meridan: Crossing Aesthetics (Stanford, CA: Stanford University Press, 1999) p. 78.

14.2

In the short essay, 'The Dictation of Poetry', Giorgio Agamben produces a wonderful telling of how the tight unity between life and speech, which is announced in the prologue to the Gospel of John, suffers a drastic rupture whereupon life has its ties to speech broken and becomes so-called real life. In the theological tradition that emerges from the Johanine prologue, life and speech are interlaced, but this life–language relation runs 'in precisely the opposite direction from the convention dominating the modern concept of biography'. When lived experience becomes biography (and is positioned as antecedent to language) it '*inexorably departs from speech, and becomes a real fact*'. See ibid., pp. 78 and 85.

14.3

'I dread nothing as such as autobiography. Autobiography does not exist. Yet so many people believe it exists. So here I solemnly

state: autobiography is only a literary genre. *It is nothing living*. It is a jealous, deceitful sort of thing – I detest it' [my emphasis]. Hélène Cixous, *The Book of Promethea*, trans. Betsy Wing (Lincoln and London: University of Nebraska Press, 1991) p. 19.

14.4

In Agamben's 'The Dictation of Poetry' what I am invited to see is a vision of a unity between lived experience and poeticised experience (life and speech) that lies beyond the tradition of John's Gospel and which has become truly profane. See Agamben, *The End of the Poem,* p. 85–6.

14.5

'It is . . . undeniably true, that I am speaking when I say that I am speaking.

'But things may not be that simple. Although the formal position of "I speak" does not raise problems of its own, its meaning opens a potentially unlimited realm of questions, in spite of its apparent clarity. "I speak" refers to a supporting discourse that provides it with an object. That discourse, however, is missing; the sovereignty of "I speak" can only reside in the absence of any other language; the discourse about which I speak does not pre-exist the nakedness articulated the moment I say, "I speak"; it disappears the instant I fall silent. Any possibility of language dries up in the transitivity of its execution. The desert surrounds it. In what extreme delicacy, at what slight and singular point, could a language come together in an attempt to recapture itself in the stripped-down form, "I speak"? Unless, of course, the void in which the contentless slimness of "I speak" is manifested were an absolute opening through which language endlessly spreads

forth, while the subject – the "I" who speaks – fragments, disperses, scatters, disappearing in that naked space. If the only site for language is indeed the solitary sovereignty of "I speak" then in principle nothing can limit it – not the one to whom it is addressed, not the truth of what it says, not the values or systems of representation it utilizes. In short, it is no longer discourse and the communication of meaning, but a spreading forth of language in its raw state, an unfolding of pure exteriority.' Michel Foucault, 'Maurice Blanchot: The Thought from Outside', *Foucault/Blanchot*, trans. Brian Massumi (New York: Zone Books, 1990) pp. 10–11.

14.6

The 'absolute opening' through which language endlessly spreads forth is that which offers for Foucault, as the 'unfolding of pure exteriority' (14.4), a 'passage to the "outside"'. Foucault, *Foucault/Blanchot*, p. 12.

This outside has a chance to be thought and experienced when language ceases to be brought back to interiority, of either a culture or a speaking subject. The outside is language at its own edge. The outside is no one's (the gods have long gone – were they ever there?) yet it does, for Foucault, sparkle. At the very core of language: 'the sparkle of the outside'. Ibid., p. 18.

The outside is, as Gilles Deleuze reminds us, 'something more distant than any external world'. Gilles Deleuze, 'A Portrait of Foucault', *Negotiations*, trans. Martin Joughin (New York: Columbia University Press, 1995) p. 110.

14.7

'Modern linguistics classifies pronouns as *indicators of the utterance* . . . In his studies on the nature of pronouns . . . Benveniste

identifies the essential character of pronouns . . . in their relation to the instance of discourse . . . "What is the 'reality' to which I or you refers? Only a "reality of discourse" [Émile Benveniste, 1966]'. Agamben, *Language and Death*, p. 23.

The reality to which 'I' refers is the reality of language, but in no way does this mean a loss of (so-called) real life. What needs to be held dearly is the indistinguishability of life and speech; for, with this interlacement there comes a refusal to stake out separations, isolate a 'bare' real life and thus enstate a division that, in separating 'being with the word' from 'being without the word', brings a negativity with it.

Matter

15.1

'. . . even life in its nakedness is, in truth, improper . . . if instead of continuing to search for a proper identity in the already improper and senseless form of individuality, humans were to succeed in belonging to this impropriety as such, in making of the proper being-thus not an identity and an individual property but a singularity without identity, a common and absolutely exposed singularity . . .'. Agamben, *The Coming Community*, p. 65.

Closeness

16.1

For Giorgio Agamben, Aristotle's description of the 'most authentic nature' of potentiality bequeaths to Western philosophy the paradigm of sovereignty, of Being founding itself sovereignly: 'an act is sovereign when it realizes itself by simply taking away

its own potentiality not to be, letting itself be, giving itself to itself'. Agamben, *Homo Sacer*, p. 46.

Agamben states that a defining characteristic of sovereignty is that the sovereign is capable of suspending the constitution: the sovereign is capable of saying when the law is applicable and to what it applies. As Agamben explicitly says, the definition is that of Karl Schmitt, which is made in the following words: 'the sovereign stands outside the juridical order and, nevertheless, belongs to it, since it is up to him to decide if the constitution is to be suspended *in toto*'. Ibid., p. 15.

When such suspension occurs (and for Agamben it is frequent), the constitution – let's say, rule – no longer applies. However, Agamben adds that the structure of sovereignty is not simply instated through an interdiction – *no more application of the rule*; it is, rather, instated when the rule is 'in force without significance'. The rule – constitution, law – no longer applies, yet the characteristic of sovereign power is that the rule applies through its withdrawal – the power is that of a capacity by which the rule applies in no longer applying. Simply put, the rule is in force as potentiality. And taking Jean-Luc Nancy's suggestion (see 'Abandoned Being', in *The Birth to Presence* (Stanford, CA: Stanford University Press)), Agamben will give the name ban to this potentiality, which is that aspect of potentiality that is capable of not passing into actuality. Through the ban, the sovereign is able to presuppose its actual power.

The logic of the ban – to have the rule applying in no longer applying – is characteristic of sovereign power, and a power that is in force as its own potentiality accords with Aristotle's description of potentiality: 'The potentiality that exists is precisely the potentiality that can not pass over into actuality . . . This potentiality maintains itself in relation to actuality in the form of its suspension; it *is capable* of the act in not realising

it, it is sovereignly capable of its own im-potentiality'. Ibid.,
p. 45.

The ban corresponds to that structure of potentiality that
maintains itself in relation to actuality through an ability not to
be: 'Sovereignty is always double because Being, as potential-
ity, suspends itself, maintaining itself in a relation of ban (or
abandonment) with itself in order to realize itself as absolute
actuality (which thus presupposes nothing other than its own
potentiality)'. Ibid., p. 47.

As I see it, the logic of the ban gives primacy to actuality;
for, the power or rule that is in force without significance is 'the
proper existence of something – its actuality – undergoing its
privation'. (Take 12: Shimmering.) I cannot think it any other
way: to think potentiality in accordance with the logic of the
ban is to think passive potentiality as an actuality that is merely
deprived of itself.

Agamben admits it is hard to think potentiality freed from
the principle of sovereignty, which through the ban, and the
presupposition it makes possible, enables sovereign Being to give
itself to itself. Yet he urges us to think potentiality without a
relation to actuality, by which I understand, thinking potentiality
not as an actuality merely deprived of being in the present. *Are
we too accustomed to think in terms of the present?* (12.3)

16.2

I am here borrowing words from Michel Foucault when, as a
masked philosopher, he said: 'I can't help but dream about a
kind of criticism that would try not to judge but to bring an
oeuvre, a book, a sentence, an idea to life: it would light fires,
watch the grass grow, listen to the wind, and catch the sea foam
in the breeze and scatter it. It would multiply not judgements but

signs of existence; it would summon them, drag them from their sleep. Perhaps it would invent them sometimes – all the better. All the better. Criticism that hands down sentences sends me to sleep; I'd like a criticism of scintillating leaps of the imagination. *It would not be sovereign or dressed in red. It would bear the lightning of possible storms*' [my emphasis]. Michel Foucault, 'The Masked Philosopher', *Ethics: The Essential Works of Michel Foucault, Vol. 1* (Middlesex: Allen Lane, The Penguin Press, 1997) p. 323.

16.3

I take my cue from the concept of expression that is exposed and explored in Gilles Deleuze's *Expressionism in Philosophy*; see in particular 'Immanence and the Historical Components of Expression', pp. 169–86.

A concept of expression that is freed from any reference to transcendence is one in which, as Deleuze says: 'What is expressed has no existence outside its expression; each expression is, as it were, the existence of what is expressed. (This is the same principle one finds in Leibniz, however different the context: each monad is an expression of the world, but the world therein expressed has no existence outside the monads that express it.)' Ibid., p. 42.

This concept of expression has stayed with me since first encountering it when writing 'Serious Words' (7.2).

16.4

A concept of expression freed from any 'emanative or exemplary causality' (Deleuze, *Expressionism*, p. 180) resonates in many of the philosophical works of Gilles Deleuze. It can be found in: *The Logic of Sense*, trans. Mark Lester with Charles Stivale, ed. Constantin V. Boundas (London: The Athlone Press, 1990). It

can also be found in: 'The affection-image/Face and close-up' in *Cinema 1: The Movement Image*, trans. Hugh Tomlinson and Barbara Habberjam (Minneapolis: University of Minnesota Press, 1986).

16.5

That expression is both explication (unfolding) and implication (enfolding) is not a modern idea. In his introduction to *Expression-ism in Philosophy*, Deleuze says that expression as both explication and implication comes from a long philosophical tradition, from Christian and Jewish Neoplatonism through to the Middle Ages and the Renaissance. 'To explicate is to evolve, to involve is to implicate. Yet the two terms are not opposites: they simply mark two aspects of expression . . . Expression in general involves and implicates what it expresses, while also explicating and evolving it'. Deleuze, *Expressionism in Philosophy*, p. 16.

16.6

There is no subject called lighting 'behind' the flash. This is again to reference Nietzsche (13.1).

16.7

'[Expression's] momentum carries a charge of potential too great to be absorbed in any particular thing or event: too much to be born(e)'. Massumi, 'Introduction: Like a thought', *A Shock to Thought*, p. xxxii.

16.8

' . . . an Outside that's further from us than any external world, and thereby closer than any inner world'. Deleuze, *Negotiations*, p. 97.

The 'irrational cut' that is to be found in modern cinema and which opens up an 'interstice' between images (audio or visual) brings into play 'an outside more distant than any exterior, and . . . an inside deeper than any exterior . . . ' See Gilles Deleuze, *Cinema 2: The Time-Image*, trans. Hugh Tomlinson and Robert Galeta (London: The Athlone Press, 1989) p. 261.

Endeavour

17.1

At least sixteen attempts of finding out what I can say and with this has come, equally, sixteen attempts of finding the right moment to 'punctuate' the discourse and to stop speaking. It has been said that Jacques Lacan was the master of the short seminar, which often left those listening uncertain as to the question being asked. In his teaching, Lacan drew upon his psychoanalytical practice and, as Catherine Clément says, he was a 'master of analytic technique . . . rather than calmly allow the time to pass and the patient to come to the end of his allotted three-quarters of an hour, the analyst searches for the right moment to "punctuate" his discourse, to stop speaking . . . the "punctuation" of the session invariably shortens its duration . . . ' Catherine Clément, *The Lives and Legends of Jacques Lacan*, trans. Arthur Goldhammer (New York: Columbia University Press, 1983) pp. 114–15.

Personal

18.1

'It is when the language system overstrains itself that it begins to stutter, to murmur, or to mumble; then the entire language reaches the limit that sketches the outside and confronts silence.

When the language system is so much strained, language suffers a pressure that delivers it to silence. Style – the foreign language system inside language – is made by these two operations; or shall we rather speak, with Proust, of a nonstyle, that is, of "elements of a style to come which do not yet exist"?' Gilles Deleuze, 'He Stuttered', *Gilles Deleuze and the Theatre of Philosophy*, eds, Constantin V. Boundas and Dorothea Olkowski (New York and London: Routledge, 1994) p. 28.

18.2

Take 2 of this volume confronts the aporia of language's passion yet baulks at the idea that because of it there is no other option to presuppose 'language's open face', which now I can say is language's potentiality for expression.

18.3

Language is able to give expression to the light that falls so piercingly this morning; however, the 'expressible' is not a thing but rather a thing in so far as it has entered into language.

18.4

As the philosopher Gilles Deleuze reminds us, time and time again, the world has no existence outside of its expressions.

18.5

Paul Celan, 'Conversation in the Mountains', *Collected Prose*, trans. Rosmarie Waldrop (Manchester: Carcanet Press, 1999) p. 22. The poet Paul Celan wrote very little prose and in this slim volume the text to which Celan himself gave most importance

is 'Conversation in the Mountains'. When I first read this text it took my breath away . . .

'One evening, when the sun had set and not only the sun, the Jew – Jew and son of a Jew – went off, left his house and went off, and with him his name, his unpronounceable name, went and came, came trotting along, made himself heard, came with a stick, came over stones, do you hear me, you do, it's me, me, me and whom you hear, whom you think you hear, me and the other – so he went off, you could hear it, went off one evening when various things had set, went under clouds, went in the shadow, his own and not his own – because the Jew, you know, what does he have that is really his own, that is not borrowed, taken and not returned – so he went off and walked along this road, this beautiful, incomparable road . . . ' Ibid., p. 17.

18.6

On being asked if Hannah Arendt might find in his work traces of a kind of totalitarianism, of the belief that in some sense 'everything is possible', which is what could arise when the words 'the totality of possibilities' are uttered, Alain Badiou says: 'The conception of politics that we defend is far from the idea that "everything is possible." In fact, it's an immense task to try to propose a few possibilities, in the plural, *a few possibilities other than what we are told is possible*. It is a matter of showing how the space of the possible is larger than the one we are assigned – that something else is possible, but not that everything is possible' [my emphasis]. Alain Badiou and Peter Hallward, 'Politics and Philosophy: An interview with Alain Badiou', *Angelaki*, Vol. 3, No. 3, 1998, p. 121.

Badiou's most general goal has been described as an effort to expose the potential of radical innovation in any situation.

'Every such innovation can only begin with some sort of exceptional break with the status quo, an "event"'. Peter Hallward, 'Beyond Formalism: An Interview, *Angelaki*, Vol. 8, No. 2, 2003, pp. 111–12.

Beside, and paraphrasing

19.1

These words are from the medieval thinker Meister Eckhart as quoted by Giorgio Agamben, *The Coming Community*, p. 74.

19.2

These words are Giorgio Agamben paraphrasing the above words of Meister Eckhart. Ibid.

19.3

'If the syntagm "I love you" is uttered as an example of a performative speech act, then this syntagm both cannot be understood as in a normal context and yet still must be treated as a real utterance in order for it to be taken as an example. What the example shows is its belonging to a class, but for this very reason the example steps out of its class in the very moment in which it exhibits and delimits it (in the case of a linguistic syntagm, the example thus *shows* its own signifying and, in this way, suspends its own meaning). If one now asks if the rule applies to the example, the answer is not easy, since the rule applies to the example only as to a normal case and obviously not as to an example. The example is thus excluded from the normal case not because it does not belong to it but, on the contrary, because it exhibits its own belonging to it. The example is truly a *paradigm* in the etymological sense: it is what is "shown beside", and class can

contain everything except its own paradigm'. Agamben, *Homo Sacer*, p. 22.

19.4

Here I am modifying a passage in *The Coming Community* that opens with the words, 'The being-such of each thing is the idea.' It would seem that for Giorgio Agamben, the idea (at least, what he asserts is a Gnostic reading of the Platonic idea) and the example share the same paradigmatic existence. The passage ends with the following words: 'The existence of the idea is, in other words, a paradigmatic existence: the manifesting beside itself of each thing (*paradeigma*). But this showing beside itself is a limit – or, rather, it is the unraveling, the indetermination of a limit: a halo'. Agamben, *The Coming Community*, p. 101.

19.5

These words can be found in Giorgio Agamben's *What is a Paradigm?* a lecture given at the European Graduate School, Saas-Fee, Switzerland, 2002, available at http://www.egs.edu/faculty/agamben/agamben-what-is-a-paradigm-2002.html The words can also be found in the essay 'The Thing Itself'. In this essay, Agamben pays philological attention to details and considers the Platonic idea as that 'by which' the thing is known. It has to be said, again, that the idea and the example appear to have the same paraexistence and manner. The Platonic idea is 'knowability itself', but the idea is not to be thought of as '*another thing*, as a duplicate of the thing before or beyond the thing'. The idea is 'not another thing but the thing *itself*; not, however, as supposed by the name and the logos, as an obscure real presupposition (a *hypokeimenon*), but rather in the very medium of its knowability . . . ' See Agamben, 'The Thing Itself', *Potentialities*, pp. 32–3.

19.6

Giorgio Agamben speaks of Michel Foucault – and also himself – as working with a paradigmatic method. A concrete phenomenon functions as a paradigm (an example) and will decide 'a whole problematic context' that it both 'defines and makes intelligible'. Agamben, *What is a Paradigm?*

In order to problematise a conception of power that would take the workings of power as belonging primarily to the category of repression and equally to show that truth is not by nature free, Michel Foucault works with confession as an example of a production that is 'thoroughly imbued with relations of power.' Michel Foucault, *The History of Sexuality, Volume 1: An Introduction*, trans. Robert Hurley (New York: Pantheon Books, 1978) p. 60.

Foucault took the confession as the exhibition of the intelligibility of a problematic, but that which was problematised was not presupposed; on the contrary, it was 'reached and constructed by means of paradigms'. See Agamben, *What is a Paradigm?*

Unfixed

20.1

Giorgio Agamben says: 'it is from the hundred idiosyncrasies that characterize my way of writing the letter p or of pronouncing its phoneme that its common form is engendered.' Agamben, *The Coming Community*, p. 20.

Borrowing from Agamben the letter *p* as an example, Thomas Carl Wall says: 'Each individual *p* opens onto an exemplarity, a singularity, that is its oscillations – a vicarious space where each individual *p* substitutes itself for each other possible *p* such that this particular p is incarnated as substituted.' In this community 'each being occupies a particular place that is radically in question

as it opens into another space where *each being is always already substituted for another being who is in an always other place'* [my emphasis]. Thomas Carl Wall, *Radical Passivity: Levinas, Blanchot, and Agamben* (Albany: State University of New York Press, 1999) p. 127.

In many respects this describes the community called Bada-liya, which Agamben cites in *The Coming Community* and which the Arabist Louis Masignon founded. The name Badaliya derives from the Arabic term for 'substitution' and those who became mem-bers of its community took a vow to 'live *substituting themselves* for someone else, that is, to be Christians *in the place of others* . . . substituting oneself for another does not mean compensating for what the other lacks, nor correcting his or her errors, but *exiling oneself to the other as he or she is* in order to offer Christ hospi-tality in the other's own soul, in the other's own taking-place. This substitution no longer knows a place if its own, but the taking-place of every single being is always already common – an empty space offered to the one, irrevocable hospitality'. Agamben, *The Coming Community*, pp. 23–4.

20.2

'. . . the idea is that which intervenes every time to shatter the pretense of absoluteness . . . ' Agamben, *The Coming Community*, p. 76.

The 'idea' I find in Agamben and which shares the same paraexistence as the example is contra to a fixed idea; it is an idea that unfixes.

20.3

'. . . this letter *p* that I make here is itself not because it belongs to an ideal *p*-form but because it belongs among, or borders

on, *all* the various differences and idiosyncrasies in innumerable versions of *p*'. Wall, *Radical Passivity*, p. 127.

20.4

Following Spinoza, Gilles Deleuze takes care to distinguish an immanent cause from an emanative cause. *A cause is immanent . . . when its effect is 'immanate' in the cause, rather than emanating from it (7.2)*. Paying attention to etymological details, Giorgio Agamben points out how Deleuze's use of immanate 'displaces the origin of the term "immanence" from *manere* ("to remain") to *manare* ("to flow out")'. For Deleuze, what defines an immanent cause is that its effect is in it – *in it, of course, as in something else, but still being and remaining in it (7.2)*. With immanence there is a flowing out, yet this rising forth, 'far from leaving itself, remains incessantly and vertiginously within itself'. Agamben, 'Absolute Immanence', *Potentialites*, p. 226.

In *The Coming Community*, Agamben again can be found paying attention to etymological details, and here the word is 'manner' – *maneries*. Citing medieval logic, we will find Agamben saying that manner is neither generic nor particular: 'It is an exemplar . . . ' Having cited Uguccione da Pisa's definition of manner – 'Species is called manner as when one says: grass of this species, that is, manner grows in my garden' – Agamben goes on to say: 'It is probable, then, that the term *maneries* derives neither from *manere* (to express the dwelling place of being in itself . . .) nor from *manus* or hand (as the modern philologists would have it), but rather from *manare*, and thus it refers to being in its rising forth'. Agamben, *The Coming Community*, pp. 27–8.

With the example, we find a *manner of rising forth* – can I say this?

Lesson

21.1

In this volume the child is taught that, in order to speak about something, the existence of names must be presupposed. This presupposition marks the facture in language between name and defining discourse (6.5).

21.2

'Benveniste identifies the essential character of pronouns . . . in their relation to the instance of discourse . . . pronouns . . . are presented as "empty signs", which become "full" as soon as the speaker assumes them in an instance of discourse . . . *Deixis*, or indication – with which their [pronoun's] peculiar character has been identified, from antiquity on – does not simply demonstrate an unnamed object, but above all the very instance of discourse, its taking place. The place indicated by the *demonstratio*, and from which only every other indication is possible, is a place of language. Indication is the category within which language refers to its own taking place'. Agamben, *Language and Death*, pp. 23–5.

21.3

The characteristic of the pronoun to refer back to a preceding term is called anaphora.

21.4

Giorgio Agamben says that the two characteristics that according to grammarians define the meaning of the pronoun – 'ostension and relation, *deixis* and anaphora – have to be completely rethought. He goes on to say: 'Pure being (the *substantia sine*

qualitate), which is in question in the pronoun, has constantly been understood according to the schema of presupposition. In ostension, through language's capacity to refer to the instance of discourse taking place, what is presupposed is the immediate being-there of a non-linguistic element, which language cannot say but only show (hence showing has provided the model for existence and denotation, the Aristotelian *tode ti*). In anaphora, through reference to a term already mentioned in discourse, this presupposition is posited in relation to language as the subject (*hypokeimenon*) that carries what is said (hence anaphora has provided the model for essence and meaning, the Aristotelian *ti hen einai*). The pronoun, through *deixis*, presupposes relationless being and, through anaphora, makes that being "the subject" of discourse. Thus anaphora presupposes ostension, and ostension refers back to anaphora (insofar as deixis presupposes an instance of discourse): They imply each other . . . The originary fracture of being in essence and existence, meaning and denotation is thus expressed in the double meaning of the pronoun, without the relationship between these terms ever coming to light as such. What needs to be conceived here is precisely this relation that is neither denotation nor meaning, neither ostension nor anaphora, but rather their reciprocal implication.' Agamben, *The Coming Community*, pp. 94–5.

21.5

It is glorious to see an appearance that has nothing hidden or withdrawn from it; it is also glorious to see that with the double movement that opens up the delicate interval in which a sheer appearance of *as* arises there is a reciprocal implication of language showing (denotation) and language meaning. And why this is glorious to see is because, with this reciprocal implication, I

no longer see a fracture 'between name (*onoma*) and defining discourse (*logos*)' (6.5).

An example

22.1

This photographic image was produced collaboratively with Vit Hopley.

For this photographic image to be held up as an example, I first have to say – *This is an example*. With that being said I am saying that this photographic image shows you what a photographic image can be; it is, as such, a *potentia*, in itself a possibility that opens onto all those other possibilities, no one of which is definitive. Having said this, there comes yet another thought: What if the photographic image was to be considered as existing in the paradigmatic position of the example? Here the photographic image would be showing the world beside itself; the photographic image would not be it, yet the photographic image would be nothing other than it. As an example, the photographic image would give a view, yet this view – this *image* – would not be bound by something that is already established. It would not be a representation. For with the example there is no play of absence and presence. But there is exposition, and this shows not what the world 'has been' but, rather, what the world *can* be. Simply put, the photographic image would show *potentia*.

A vision

23.1

'It's very important to observe this neutralisation of reference which defines the example. For instance, I say "I swear" as an example of the performative. In order to give an example of the

syntagm, "I swear" cannot be understood in the normal context as an oath . . . the specificity of the paradigm resides precisely in the suspension of its immediate factual reference . . . ' Agamben, *What is a Paradigm?*

23.2

In becoming an example there is a chance of being a free spirit: '. . . any particular can appear as what it is without being confined to any of the actual particularities of its appearance. Agamben, quite appropriately, calls this an "example"'. Wall, *Radical Passivity*, p. 144.

23.3

You will hear Giorgio Agamben saying: 'It is not the non-linguistic, the relationless object of pure ostension, nor is it this object's being in language as that which is said in the proposition; rather, it is the being-in-language-of-the-non-linguistic, the thing itself'. Agamben, *The Coming Community*, pp. 95–6.

23.4

The term 'expressible' (*lekton*) was introduced by the Stoics to name the modification undergone by a body or thing (states of affairs) as it becomes a matter of a statement. For the Stoics, the expressible has an incorporeal status and is irreducible to either the sign/signifer or its actual referent. In his introduction to *Potentialities*, Daniel Heller-Roazen will say that, for the philosophers of the Stoa, the expressible is not 'a real determination of a body' but, rather, an incorporeal transformation that subsists in every utterance: 'The expressible is thus not a thing but rather the thing insofar as it has entered into speech and thought . . . ' The term 'expressible' identifies and names an event, which indicates

the taking-place of language, and a mode, which is precisely the mode of being of what exists in language.

Being the thing insofar as it has entered into language, the expressible is reminiscent of Plato's 'thing itself' (*to pragma auto*), which refers to 'that part of a thing that renders it "knowable" in language'. The thing itself is that through which knowability is possible in language, but it is not itself a particular being; indeed, it is not another thing ('a duplicate of the thing before or beyond the thing'), yet it is not simply identical to the thing or body or being whose apprehension it makes possible.

The expressible is not the thing, yet it is not another thing; it is the thing not separated from itself but beside itself in the medium of its sayability in language — it is the thing 'itself' (no presupposition) and precisely the thing itself of language. And when Latin translates the Greek *lekton*, the expressible becomes the 'sayable'. See Heller-Roazen, 'Editor's Introduction', *Potentialities*, pp. 9–13.

23.5

What must not be lost sight of is the question of what, in a given situation or period, can be said and which is a determination of matters in speech, which includes writing. Acknowledging the tremendous work of Michel Foucault, it must be said that this determination is a historical, aesthetico-political production — *What are we able to say today?*

Of Foucault's endeavours, Gilles Deleuze puts it succinctly when he says: 'What Foucault takes from History is that determination of the visible and articulable features unique to each age which goes beyond any behaviour, mentality or set of ideas, since it makes these things possible.' Gilles Deleuze, *Foucault*, trans. Seán Hand (London: The Athlone Press, 1999) pp. 48–9.

It is not at all a matter of an 'age' pre-existing the 'statements' that express it. On the contrary, each historical formation implies, as Deleuze puts it, 'a distribution of the visible and the articulable which acts upon itself'. Ibid., p. 48.

In short, what can be said – the articulable, the sayable – and what can be seen – visibilities – have a direct bearing on practices and concrete situations; for example, disciplinary rules at school or in the army. Take what Foucault shows in *The History of Sexuality*: rather than a repression of matters of sexuality, the Victorian age is 'teeming with statements of sexuality, determining its conditions, systems, places, occasions and interlocutors . . . ' Ibid., p. 53.

Moreover: 'Take madness in the seventeenth century, for instance: in what light can it be seen, and in what utterances can it be talked about. And take us today: what are we able to say today, what are we able to see? Deleuze, *Negotiations*, p. 96.

To ask 'What are we able to say today?' is equally to ask 'How are we apprehending language today?' Or better still, 'What are we capable of apprehending of the "there is" of language today?' And the question of what can be apprehended is central to Jacques Rancière's key study, which is the *distribution of the sensible*. I offer here, for brevity's sake, the 'pragmatic indication' that is given in the glossary of technical terms to be found in Rancière's *The Politics of Aesthetics*: 'Occasionally translated as the "partition of the sensible", *le partage du sensible* refers to the implicit law governing the sensible order that parcels out places and forms of participation within which these are inscribed. The distribution of the sensible thus produces a system of self-evident facts of perception based on the set horizons and modalities of what is visible and audible as well as what can be said, thought, made, or done. Strictly speaking, "distribution" therefore refers both to forms of inclusion and to forms of exclusion. The "sensible", of

course, does not refer to what shows good sense or judgement but to what is *aisthēton* or capable of being apprehended by the senses'. See Jacques Rancière, *The Politics of Aesthetics: The Distribution of the Sensible*, trans. Gabriel Rockhill (London and New York: Continuum, 2006) p. 85.

In the interview that accompanies the English edition of the above volume, Rancière says that his approach is 'a bit similar to Foucault's'. He goes on to say: 'It . . . replaces the dogmatism of truth with the search for conditions of possibility. At the same time, these conditions are not conditions for thought in general, but rather conditions immanent in a particular system of thought, a particular system of expression'. Ibid., p. 50.

23.6

Let it be said: this is the phenomenon existing in the mode of potentiality.

23.7

It is in the delicate interval where a sheer *as* arises that the pure passion of language can appear and bring no presupposition with it. That apprehension of this interval, this utter in-the-midst-of-as, has occurred is thanks to (at least in this volume) the demonstrative pronoun showing the reciprocal implication of *this* and *that*, denotation and meaning; it is also thanks to the example for giving neither immediate factual reference and the denotation of *this* nor the definitive meaning of *that*.

A question in the making

24.1

These words of Plato are quoted, with audacity, from Giorgio Agamben, 'The Thing Itself', in *Potentialities*, p. 29.

The Platonic 'thing itself', with which Stoic linguistic theory chimes, is that part of an entity that renders it knowable, sayable, in language. Agamben will put it like this: 'The thing itself . . . is . . . possible only in language and by virtue of language: precisely the thing of language . . . The thing itself is not a thing; it is the very sayability, the very openness at issue in language, which, in language, we always presuppose and forget . . . ' Ibid., pp. 31 and 35.

The 'thing itself' is the pure taking-place in language that is not itself a thing but the sayability of the thing in language.

In his *Seventh Letter*, Plato recounts how he attempted to show Dionysius, the tyrant of Syracuse, the fundamental thought with which his philosophy is concerned. However, Plato declares that no written exposition of this is possible and that he himself has never written and will never write a treatise about it: 'There does not exist, nor will there ever exist, any treatise of mine dealing with this thing. For it does not at all admit of verbal expression like other disciplines [*mathēmata*], but, after one has dwelt for a long time close to the thing itself [*peri to pragma auto*] and in communion with it, it is suddenly brought to birth in the soul, as light that is kindled by a leaping spark . . . ' As quoted ibid., pp. 28–9.

Plato does not want the 'thing itself' to be turned into a subject (which the presuppositional structure of language is happy to do); for, this would be to have the very thing taken as given and, as Agamben stresses, what is for Plato the essential matter for human beings is that, in thought, speech and life, they cease presupposing and reach, as Plato puts it, an 'unpresupposed principle'. And that which is suddenly brought to birth in soul, as light that is kindled by a leaping spark, is, for Plato, language taking-place, and the thing taking-place within it, without presupposition – indeed,

the thing itself. See Agamben, 'The Idea of Language', *Potentialities*, p. 47.

24.2

In his introduction to *Potentialities*, Daniel Heller-Roazen suggests that, in the *Logic of Sense*, Deleuze defines the event with reference to the Stoic doctrine of the expressible. See Agamben, *Potentialities*, p. 13.

It is in terms of 'sense' that the Stoic doctrine of the expressible and the event come together in the *Logic of Sense*: 'Sense is the fourth dimension of the proposition. The Stoics discovered it along with the event: sense, *the expressed of the proposition*, is an incorporeal, complex, and irreducible entity, at the surface of things, a pure event which inheres or subsists in the proposition . . . [sense] is related to propositions as what is expressible or expressed by them, which is entirely different from what they signify, manifest or denote. Gilles Deleuze, *The Logic of Sense*, trans. Mark Lester with Charles Stivale, ed. Constantin V. Boundas (London: The Athlone Press, 1990) pp. 19 and 167.

Deleuze calls for a kind of seer (*voyant*) that witnesses the event, which is what an actual situation – a state of affairs and the mixing of bodies – produces as a sort of incorporeal vapour. To consider the expressible as this incorporeal event brings the thought that in the delicate interval in which the pure passion (*potentia passiva*) of language opens there arises the temporality that pertains to event, which is the empty form of time that, in *What is Philosophy*, is the 'dead time' of a meanwhile – *un entre-temps* – that belongs to becoming. Deleuze and Guattari, *What is Philosophy*, p. 158.

In Deleuze's *The Time-Image*, this form of time is what the *voyant* sees in the 'interstice' that in modern cinema sometimes

opens between images (audio or visual) and is called 'irrational' (following modern mathematics) because it produces an interval that, whilst separating or 'tracing a border', does not belong to (as the end of one or the beginning of the other) that which it separates or delimits. See Deleuze, *The Time-Image*, pp. 1–8, 179–181 and 277–79.

24.3

'As anaphora, the term *thus* refers back to a preceding term, and only through this preceding term does it (which, in itself, has no meaning) identify its proper referent.

'Here, however, we have to conceive of an anaphora that no longer refers back to any meaning or any referent, an absolute *thus* that does not presuppose anything, that is completely exposed'. Agamben, *The Coming Community*, p. 94.

And later you will hear Agamben saying that *thus*, which means 'yes', is the name of language. Ibid., pp. 103–4.

Dividing the division

25.1

It is undeniable that within language a presuppositional machine operates – do we not learn to presuppose through language? A first move is to see this operation, that is to say, to see how presupposition produces and maintains division between the event of language and what is said within this event, the name and meaningful discourse and, finally, the 'linguistic' and 'non-linguistic'. A second move (requiring perseverance and desire going hand in hand and, perhaps, faith) is to see when, in language, the presuppositional machine becomes inoperative. This is what the

philosopher Giorgio Agamben is asking us to see, and this *vision* (of language) freed from presupposition is not without political implications. It has made me happy that in the writing of this volume I have been able to see presupposition inoperative when 'sayability', or 'expressibility', shows a pure relationship with the taking-place of language and the existence of potentiality (*passionate being*) and, equally, when the demonstrative pronoun shows the reciprocal implication of denotation and meaning with which arises a sheer *as*. And it has to be said that happiness is the key (political) issue. To see through the presuppositional structure of language and catch sight of the taking-place of language – and the world – freed from presupposition is to have apprehension of living a life that has nothing but its own living at stake within it, that is, of existing without presupposition.

– 'Is today something like . . . a life for which itself would be at stake in its own living, possible? Is today a *life of power* [*potentia*] available?' Agamben, *Means without End*, p. 9.

Call it a life of desire and perseverance going hand in hand. Call it a life lived in pure immanence. Call it singularity. Call it 'happy life'.

25.2

In his commentary on Paul's letter to the Romans, Giorgio Agamben draws our attention to a division that divides the division between the Jew and the non-Jew and produces the non-non-Jew. The 'division of divisions', Agamben will call the Pauline aphorism.

'. . . Paul puts another division to work, one that does not coincide with the preceding ones but that is not exterior to them either . . . This partition does not coincide with that of the Jew/non-Jew, but it is not external to it either; instead,

it divides the division itself'. Giorgio Agamben, *The Time That Remains: A Commentary on the Letter to the Romans*, trans. Patricia Dailey, Meridian: Crossing Aesthetics (Stanford, CA: Stanford University Press, 2005) p. 49.

In dividing the division, no final ground is reached: 'No universal man, no Christian can be found in the depths of the Jew or the Greek, neither as a principle nor as an end; all that is left is a remnant and the impossibility of the Jew or the Greek to coincide with himself . . . Jew *as non*-Jew, Greek *as non*-Greek'. Ibid., pp. 52–3.

25.3

On the very last page of *The Open*, Giorgio Agamben suggests that each and every division that serves to separate the human from the animal has at its core an emptiness: '. . . in our culture man has always been the result of a simultaneous division and articulation of the animal and the human, in which one of the two terms of the operation was also what was at stake in it. To render inoperative the machine that governs our conception of man will therefore mean no longer to seek new – more effective or more authentic – articulations, but rather to show the central emptiness, the hiatus that – within man – separates man and animal, and to risk ourselves in this emptiness . . . ' Giorgio Agamben, *The Open: Man and Animal*, trans. Kevin Attell, Meridian: Crossing Aesthetics (Stanford, CA: Stanford University Press, 2004) p. 92.

Writing the Image

An Adventure with Art and Theory

Yve Lomax

Yve Lomax has developed a writing practice that constitutes an adventure with visual art practice and theoretical writing. Running through this collection of her writings is a common thread, placing writing itself – the written image – into the repertoire of visual art.

Writing the Image can be read and enjoyed as performance, often resembling poetry, thick with ideas, images and metaphors; it is also an original contribution to theoretical writing on the visual, particularly relating to questions of difference and time. It celebrates the work of Michel Serres, Gilles Deleuze and others in pursuit of its own strategy of introducing the written image into the theoretical text.

The book also includes a contribution from Irit Rogoff.

'The buoyant spirit motivating Lomax's endeavours is infectious – like laughter – and opens up lots and lots of possibilities quivering on the threshold of everyday life.' – Deborah Garwood, *Art Journal*

Sounding the Event

Escapades in Dialogue and Matters of Art, Nature and Time

Yve Lomax

Sounding the Event continues Yve Lomax's commitment to the practice of writing as a visual artist; it proposes that 'to think' is an event, inviting both listening and laughter.

Sounding the Event asks: What constitutes an event? Propelled by this question, it encounters a variety of theories and in sounding them out hears of a host of issues that have implications for not only conceptions of nature and becoming, subject and substance, but also practices of time, art and photography along with theory and its manner of speaking.

Sounding the Event experiments with modes of speech and explores dialogue in its writing; it makes us literally hear the thinkers it encounters, including Michel Serres, Isabelle Stengers, Jean-François Lyotard, Maurice Blanchot, Gilles Deleuze and Félix Guattari, and Alain Badiou.

'In Sounding the Event, *Yve Lomax filters philosophical axioms through ordinary speech with such fluidity that the process of thinking the permeability of knowledge seem almost palpable.'* – Mary Kelly